PHILLIP KING

Hayward Gallery, London
24 April – 14 June 1981

Arts Council of Great Britain

© Arts Council of Great Britain 1981
ISBN 0 7287 0276 2

Exhibition organised by Catherine Lampert
assisted by Rosalie Cass

Catalogue designed by Roger Huggett, Sinc
Composition by Filmtype Services Limited, Scarborough.
Printed in the Netherlands by L. Van Leer & Company Ltd

Photographs by Cavendish Photographic, Chris Davies,
Hugh Gordon, Errol Jackson, Valerie Josephs, Michael Leonard,
J. S. Lewinski, R. Lucking, Photostudio Ltd, Eileen Tweedy,
John Webb

Preface

Although the Arts Council has regularly organised retrospective exhibitions of British artists, only a modest proportion have been devoted to the work of sculptors. The principal obstacle is space, and indeed in the present retrospective there are only 42 works. However, they have been judiciously selected by the artist not only for their individual importance but also to extend the viewer's understanding of their common origins and ambitions revealed by juxtaposing works of various periods. The second factor which limits exhibitions of contemporary sculpture is the great amount of time and care it takes to assemble objects of diverse and delicate materials like the painted surfaces and mixed media of King's sculpture. The artist has sacrificed valuable studio time, and we are indebted to him, to the Rowan Gallery and to Julian Hawkes and Valerie Josephs for their unstinting help.

Phillip King's sculpture has been commissioned and collected by an international group of museums, industrial and public bodies and private admirers who have each in turn recognised his ability to combine an imaginative and human touch with a consistently professional approach. The Arts Council owes much to the lenders for their willingness to allow major sculptures to travel (12 works will also be seen in Edinburgh in September).

King is known too as an effective teacher and partisan of younger sculptors. We hope they and the public will respond to the opportunity of seeing the work of an unusually independent artist in mid-career. We would also like to thank the three writers, R. W. D. Oxenaar, Robert Kudielka and Lynne Cooke for their sensitive interpretations of King's achievement.

JOANNA DREW
Director of Art

CATHERINE LAMPERT
Exhibition Organiser

Lenders to the exhibition

Arts Council of Great Britain

Collection Ulster Museum, Belfast

Royal Museums of Fine Arts of Belgium, Brussels

Bradford Art Galleries and Museums

The British Council

Anthony Caro

Government Art Collection

Lily Modern Art Gallery, Jersey

University of Liverpool

City of Antwerp, Openair Museum for Sculpture, Middleheim

Collection of Mrs. John D. Murchison, USA

Kröller-Müller National Museum, Otterlo, Netherlands

Musée National d'Art Moderne – Centre Georges Pompidou, Paris

Bryan Robertson

Romulus Construction Company

Rowan Gallery, London

City of Rotterdam

Mrs. Belle Shenkman

The Trustees of the Tate Gallery

Christopher Todd

and the artist and a number of private collections

Contents

Introduction

The sixties and seventies have been an important period for sculpture. The changes in that field during those two memorable decades have had an impact on art that seems to be more essential than whatever happened in painting or in any other categories. Be it only that especially through sculpture those classical categories became clearly obsolete.

It started with what Jack Burnham called 'the urge to create *objects*, that is three-dimensional entities that did not resemble sculpture – that were even asculptural'. It went on for example within the context of Carl Andre's definition: form = structure = place and could culminate in a written conception as sediment and result as a product of creative thinking.

In the now historical New York exhibition *Primary Structures* in 1966 a selection of those artists who dared to break away from an over-bearing older generation were presented for a moment as a united group with work of like-minded intentions. So as in the same way just a few years earlier a differently orientated group of younger artists was presented in the *Nove Tendencije* exhibitions in Zagreb. From *New Tendencies* and *Primary Structures* ideas fanned out into the world, new definitions were formulated, new styles emerged often jealously defended within a limited range of ideas and as always some individual artists went their own way and grew to stand for what really inspired a new generation.

The American and British sculptors of that generation have never again been shown together as even in principle congenial artists. Minimal Art and the London Scene, where Bryan Robertson could present a new generation every year and where I heard him coin the term 'Pop Arp' for what happened in British sculpture, could not possibly be on the same wavelength. Only Anthony Caro, the father of the St Martin's generation of British sculptors became a durable link between England and America, between here and there, Europe and the USA.

Between the continent and the new world Phillip King's work was born and grew to maturity in this period. It started with *Declaration* precisely in 1960 and in twenty years a versatile and consistent oeuvre came into being that made him without doubt or assail the most impressive representative of his generation in Great Britain. A position that slowly but surely brought him international acknowledgement.

If one tries to situate King's contribution to sculpture within the international context of his time and generation it is both simple and complicated to find the right co-ordinates to clarify his position.

I am inclined to think that his English contemporaries will

agree that he is the one who stands out in their group. This of course is certainly not true for as far as his American contemporaries are concerned. The gap between industry and craft, between concept and emotion, between a new and an after all old world approach, is such that Minimal and King do not group.

But how about the continent? The work of Phillip King has been seen and is known in Europe. He has had personal exhibitions in Holland and in France, he showed at the Biennale in Venice and was included in group shows in many countries. He has had major commissions in Germany and in Holland. In that last country it is even possible to trace the direct influence of his work on a younger generation.

Nevertheless it is difficult to find a worthy counterpart or equal for him on the continent. He is not to be compared with Arte Povera in Italy, Ulrich Rückriem in Germany has other concerns, in France nothing much happened in that period that could be compared. In Holland one thinks of the older Cárel Visser and perhaps of his contemporary Cornelius Rogge. Of course one always immediately finds that sort of sculpture everywhere, but when it matters few stand up to the test. Also, British sculpture has its own flavour and King represents that particular brand on it most penetrating and intrinsic level. Personally I feel that King is in many respects unique.

King makes 'objects' that he wants to function as personal and independent signs. His own thinking about his position in the world and the meaning of his work makes me dare to write about him in terms of what Lévi-Strauss means when he uses the word 'bricoleur'. That is: 'the intellectual who translates his ideas and classifications into the poetry of the received idiom in order to get his ideas across'. Time and again King produces personal signs as 'a link between images and concepts'. He receives his idiom by the urge to start and restart from primeval ground. Sculpture for him begins with the effort to situate and elevate a piece of material. More pieces follow and slowly a constellation evolves that grows towards an ultimate moment of identification. Thereby the void has been defined and conquered in humane terms and as King has said 'sculpture is a translation or mimicry of the position of man in the world'.

His work comes into existence by direct physical and sensory contact with materials and somehow always seems to be related to nature. The characterisation of that relationship has nothing to do with imitation, but rather with the slow and laborious emergence of a parallelism. King himself sees this process as the mystery of his inspiration. It is a mark of his status as an artist that he always retraces his steps in search of the original moment, the beginning of that mystery. He has, as Matisse said: 'the courage to return to the purity of the means', and then, also in the words of Matisse: 'the perseverance to study an object a long time to know what its sign is'.

That received idiom is a gift, or, Matisse again: 'we are not masters of what we produce. It is imposed upon us'. I can only hope that King will continue to be imposed upon so as to be able to realise the consequences and that whoever wants to look at his work will really experience the fascinating results of that imposition.

RUDOLF OXENAAR
Director of the Kröller-Müller National Museum, Otterlo

Phillip King's Sculpture ROBERT KUDIELKA

One day in March 1979 I went out with Phillip King to his studio at Clay Hall Farm near Dunstable to see *Within*, a recently completed sculpture. We had a long conversation about the making of this piece, the choice of materials, the intricacies of construction and the use of natural colour. In fact, a sort of shop talk rather than a discussion of aims and aspirations. But as we were about to leave, I remarked that the piece had, despite its grand scale, a cubist insubstantiality and lightness. Phillip smiled: 'It is always the problem of mental presence, you know' – and crouching down on the dusty floor he picked up a few pieces of straw, arranged them across one another and pointed to one side. 'When you are working here, you are not restricted to this spot alone. Your mind is round the back or on any other side of the sculpture, and you are only engaged in the work when this mental duality is operative. Confinement to the matter in hand is always an indication that you are out of touch with the sculpture.'

The incident is characteristic in many ways. Phillip King is the sort of sculptor who does not believe in obsessive concentration on his work. He prefers to allow his mind to 'dwell with it', even in what might seem to be the most unlikely circumstances. A few pieces of straw were enough to lay bare the aesthetic central not only to his working method but also to his whole œuvre. However lightly expressed, the dual nature of presence is indeed the basis of any understanding of his sculpture.

It is in this context that he chooses his materials. 'It does not mean anything to me to go to a scrap yard'. (1) The matter Phillip King is looking for does not lie in the materials he finds. In the same spirit he approaches structure. There is no governing formal vocabulary. In many pieces, especially in the early seventies, he even makes one aware of this by dispensing with the central body of the sculpture. So it should hardly surprise that his development does not run along with stylistic smoothness. No other sculptor has been engaged in such a wide variety of style and technique ranging from immaculate fibreglass constructions to rough assemblages of natural materials. And yet, the more familiar one becomes with the work the less confusing its diversity appears. A King is unmistakably a King – not by virtue of any characteristic feature but through an all-pervasive immaterial distinction.

I *A certain sort of presence*

Although biographical assumptions are never fully conclusive it seems very probable that the particular character of Phillip

King's sculpture has something to do with his being brought up in North Africa. Born in Kheredine, a small village near Carthage, in 1934, he spent most of his childhood in Tunisia until in 1946 his parents moved back to England. He reveals what this period means to him by calling it 'an echo from a lot of sun'; and obliquely discloses a certain area of his plastic sensibility when he describes the appearance of Islamic architecture: 'It eats up the light in such a way that matter gets a vibration, a glitter, a quality of jewellery. Big domes, rounded forms, sit very squarely. On the other hand, the inside shows infinite elaboration. Very strong light falls on heavy masses and becomes tied to shape.' (2)

There is, of course, no literal translation of this experience to be found in his sculpture. It is rather a certain distinctly Mediterranean sense for the presence of something. Under the North African sun things do not appear as something self-sufficient, modulated by light and shade. Instead, the power of light seems to cut and throw their shape. In its shimmering febrile ornamentation and in the emphasis placed, almost defiantly, on gravity, Islamic architecture reflects this condition as eloquently as the simple copper utensils which incorporate the blazing light as though it had been actually beaten into the metal itself.

The sensibility which invests Phillip King's sculpture is less ferocious. Nevertheless it operates within a similar interplay betwixt light and gravity. In *Rosebud* 1962 it is gathered light, soft and gentle, which forms the shape of the piece; and as the quality of this light is enveloping and sheltering rather than harsh, so consequently the emphasis on gravity appears less pronounced. The sculpture sits serenely on the ground and only the arabesque opening of the pink mantle, revealing a vibrant green, makes one aware that there is a counter power to light as well.

This description may sound curiously immaterial for a sculpture. And indeed, one could regard *Rosebud* as a cone, rosy-coloured and split on one side. But if we adopt this reading the essential character of the work eludes us. No real 'subject' supports such an image. Intuitively we realise that the cone before us is an empty shell, a skin without a body. There is nothing solid to it, and this appertains not only to *Rosebud* but to other pieces as well. Suspension of 'substance' is a recurrent theme in King's oeuvre. It accounts for the important role which colour plays in his work and it even informs his late seemingly massive sculptures. *Within* 1979, for instance, owes its explosive presence to the lack of an actual core. But it was whilst working on *Rosebud* that he noted down the problem: 'an expressive form where seemingly empty parts give a paradoxically empty and at the same time loaded image.' (3)

In the development of King's work this premise has gained in importance. Whereas in early pieces such as *Rosebud* or *Genghis Khan* 1963 we can only instinctively surmise the empty centre, it is brought directly home to us in *Reel* 1968 and *Open Bound* 1973. In trying to come to terms with *Reel* the spectator is physically diverted by a circular movement, the centre of which remains inaccessible; and as a result, he is persuaded to build up his own body of sensations. The motive for such peripheral structuring has been at least partly revealed in *Open Bound*. There, an additional piece, a displaced element outside the enclosure of the main sculpture, acts as a reminder that 'substance' is not an inherent quality of things themselves. The move to 'substantialise', to centralise and consolidate an experience is a projection of our own making. We automatically tend to assume the existence of a core, a substance – i.e. a central or fundamental *something* – around which and upon which we collect and build our disparate sensations.

Phillip King challenges this seemingly natural behaviour because it prevents us from a more profound experience of reality. 'We focus, and our vision is channelled, we loose the other richer, deep reality, the glorious peripheral, where we know ourselves and others.' (4) This could sound perhaps superficial-'impressionist' in the popular sense. But the quest for the 'glorious peripheral' provides an experience of the world which proves to be more fundamental than any which a more focused emphasis on the substantial can achieve. In the North African sun, where the mind can only survive through a habitual withdrawal from reality, it is tacitly recognised that the thingness of things does not reside simply in their presence as objects of attention. (5) This realisation is not merely a climatic particularity. The natural conditions in his country of origin have only served to heighten for Phillip King the awareness of a universal truth.

In talking about his work King often uses words such as 'treeness', 'cloudiness', or 'earthboundness'. In terms of strict logic such generalisations are of course obscure because they have no identifiable object. Yet they perfectly describe the complex experience of reality before it is 'channelled', divided up and sorted out into the categories built up by our own intellect. Furthermore, these overall perceptions, loose as they may seem, constitute our most reliable and durable contact with the world. We would rapidly lose our bearings, so to

5 *Twilight* 1962

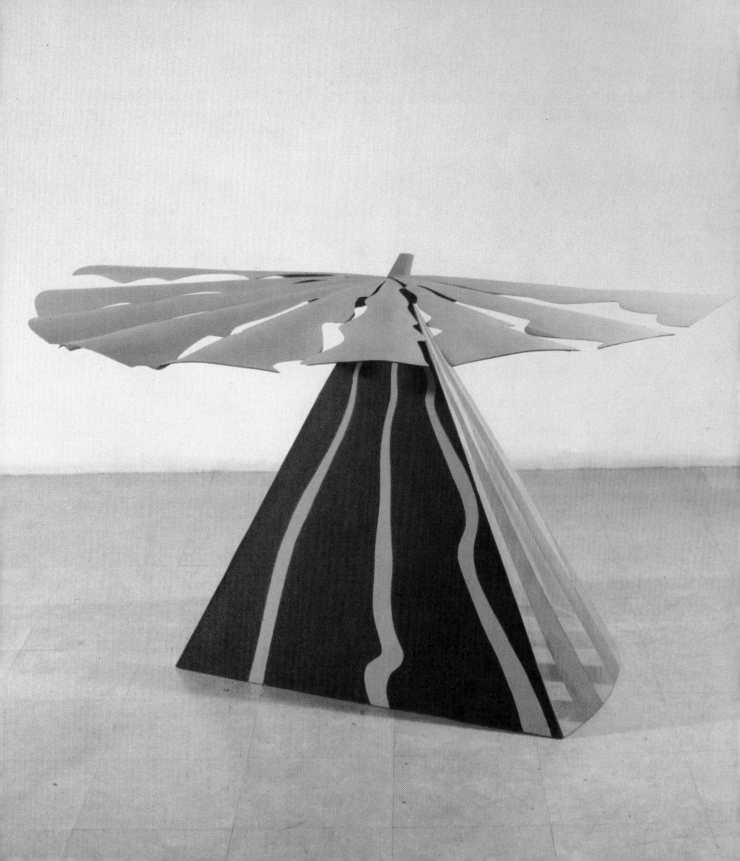

speak, if our sense of reality depended exclusively on attention being paid continually to every specific thing. Freedom of spirit relies on accepting that the world is assuredly *there*, by implication, even when we do not press our attentions. The freshness of morning, for instance, springs essentially from the vivid promise which each new day carries for us, free as yet from the laborious particularisation of the forthcoming hours; likewise, when dusk falls the spirit rises again: the soul, as the Romantics said, spreads its wings. It could be claimed that in *Twilight* 1962 Phillip King has created a kind of poetic glider for that ineffable flight when the incidental though obligatory burden of substance has been relinquished.

In this way the childhood in North Africa, far from leading to an exoticism, opened up for Phillip King the access to a primary experience which forms part of his distinction as a sculptor. With 'an echo from a lot of sun' he was able to overcome the logical contrivance of plastic sensibility which has been one of the most debilitating barriers of Western sculpture. In the European tradition a thing, and consequently the presence of a sculpture, has been defined as a substance in space and time: a persistent identity endowed with certain attributes. This may be an approved, useful and perfectly sensible aid in sorting out one's impressions and feelings. But in terms of sculpture the sheer availability of such an approach becomes detrimental, because the artist starts with a complete 'set', as it were, in his mind before he has even begun. Making is perverted into mere execution. A given posture or even the solid mass basically determines what the form is going to be; and only attributes such as expressive handling or symbolic values turn the result into a specific statement.

On the other hand it is obviously not enough to dwell upon general sensations like 'treeness' in order to make a piece of sculpture. It has to become particular, a tree-like *thing*. In order to meet such requirements King needed to develop a structural language commensurate with the complexity of his vision. How to devise a way of 'making' a tree, so to speak, which encompasses such qualities as the airiness and lightness of the crown as well as the stoutness and rootedness of its trunk? The solution can be discerned in all his work though it is perhaps most evident in *Sky* 1969 and *Ascona* 1972. The substance/attribute schema is replaced by an interplay between two fundamental forces: openness and lightness versus confinement and earthboundness. Whilst the generous arcs of *Sky* express this tension as a complementary balance, in *Ascona* King emphasised the aspect of conflict. Large curved forms writhe and

rebel within a rectangular structure against the very confinement from which they draw their power.

Although this approach is clearly related to sky and earth as its physical agents, Phillip King does not stage a cosmic drama. Nature herself is not focused on a centre, there is no heart where constituent forces are resolved; they simply meet, merge or conflict. The point of connection, the place where this anonymous drama is played out is in ourselves; it is our spirit which moves within darkness or lightness, concealment or openness. Therefore the *sense* which nature makes is open to interpretation. For instance, when Phillip King went to Japan in 1969 (on a commission for a large sculpture to be exhibited at the World Fair in Osaka) he made *Sky*, and it is clear that the pliant spirit of ancient Japan has impinged on his sensibility. The low expanse of the sculpture and its particular movement – spreading outwards and flowing back from sharply pointed extremities – reflects a sense of being betwixt sky and earth which the Japanese symbolise in their cult of the pine-tree and express in the roof structure of their temples. (6) As opposed to the European ideal of self-assertion ties with the earth are accepted in the Far East and consequently the human spirit is understood as the other invisible side to what happens 'out there', in nature.

In dispensing with the stress on substance King's work is more at ease with that which is *not* made by man. But by the same stroke his art is more spiritual than any fabricated object. *Rosebud* may be an artificial fibreglass construction and, like most of King's sculpture, an indoor piece; yet its presence is absolutely 'natural' because it embodies that aspect of nature which *needs* the human mind for recognition. Far from merely describing a botanical phenomenon – the budding of a rose – *Rosebud* is about bud-ness as distinct from, say, flowery-ness or ripeness. This double challenge however requires a profound change of our attitude as spectators. We are asked to respond to the plastic properties of the sculpture as though they were mental states as well, instead of simply regarding a physical object. The reward can perhaps best be glimpsed in *Quill* 1971. This sculpture could be compared to a spring rising from a centre and falling away to gather momentum again for a further burst. It is the structure of an exuberant spirit, the power of which could never be equalled by our resources as human beings, nor in nature as such.

However enriching in the long run, the initial shift demanded in our attitude is considerable. It is possibly an encouragement that Phillip King did not himself arrive at this way of

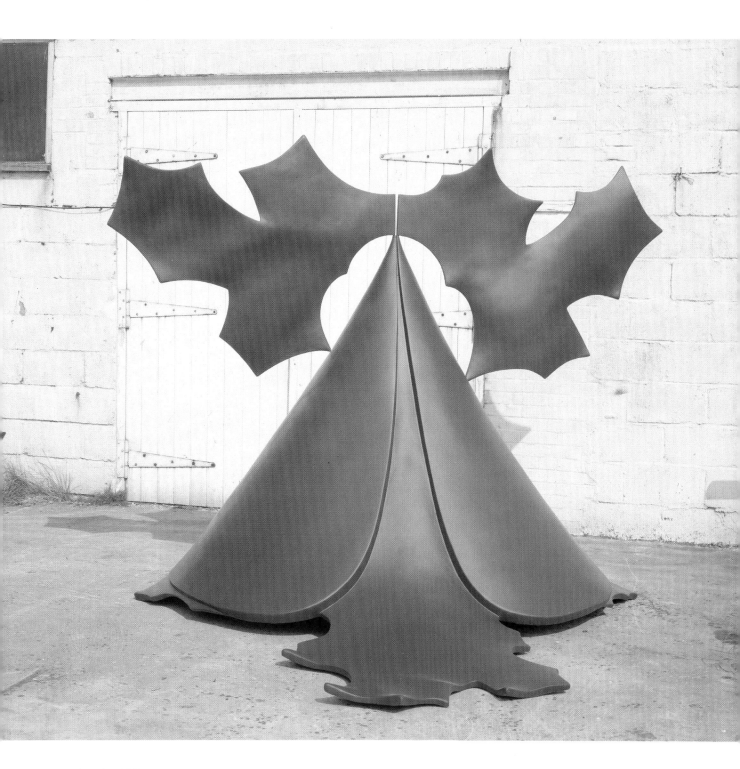

7 *Genghis Khan* 1963

working through childhood memories or mere sculptural inventiveness. He became a sculptor in the light of an experience gained as a spectator. In 1953–54 during his National Service in Paris he visited the Louvre and there he made a discovery which led to his choice of vocation: 'Whilst I was drawing and copying in the Louvre I was especially attracted by sculpture, and Greek sculpture in particular, because I realised that sculpture, more so than painting, was the art of the invisible.' (7)

2 A bit of earth, a lot of thinking and a little light at the top

To define sculpture as the art of the invisible seems to be a wildly subjective claim. We are inclined to preserve such a distinction for a less material art like painting. But in doing so one mistakes physicality for presence. Painting is in fact a more 'visible' art simply because colour is clearly artificial matter, it is a genuine medium: the place, as Cézanne said, where our mind and the universe meet. (8) Sculpture, on the other hand, can only render the spiritual in an invisible form because the material it is actually made of belongs to the realm of things. Having no medium in the strict sense of the word the sculptor is inevitably caught up in a contradictory endeavour: to express the immaterial through and against matter.

We have no difficulty in recognising this dual nature of sculpture's presence in, for example, a Buddhist figure. There the weight of the sitting body and its sensuous relaxation is clearly linked with the state of spiritual disembodiment and withdrawal. But where do we find a comparably convincing demonstration of sculpture's innate paradox in Europe? In spite of the high virtuosity frequently invested in rendering the figure a sort of inertia seems to prevail which would be intolerable to, say, an African sculptor and the reason for this curious deadness is a general tendency to eliminate the very duality which animates the work of art. Western sculpture is intended to be fully *present*: a three-dimensional image which, being self-sufficient, appears completely locked in itself.

Even in the 20th century it is difficult for an ambitious young sculptor not to be 'lulled to sleep' because this perennial curse is not restricted to representational sculpture. Or rather, representation is not the property of the figurative alone. The American Minimal sculpture of the sixties, for example, is an extreme case in point. The emphasis placed upon the self-sufficiency of the object – 'it is what it is' – does not result at all in non-representational work, as has been claimed. (9) On the contrary, the work is simply *self*-representational: it stands for nothing but itself and thus brings out into the open the European deficiency – the elimination of sculpture's essential duality.

In these circumstances it should not surprise that Phillip King is largely a self-taught sculptor. What is astounding is the tenacity with which he has remained true to his experience in the Louvre: 'sculpture as the art of the invisible'. After his return to England he began to study Modern Languages at Christ's College, Cambridge in 1954 and took his degree in 1957. During this period however he also began to make pieces of sculpture on his own which were largely derived from the example of such artists as Picasso, Matisse, Laurens and Maillol; and by now he was sufficiently involved to want to study it professionally. In the winter of 1956 he went to London and made enquiries in the Art Department of Foyles Book Shop about art schools and their Sculpture Departments. 'As a matter of fact,' the assistant replied, 'there is one just next door'.

It was the beginning of a long association with St Martin's School of Art. But before one tries to assess the role which St Martin's played in the development of Phillip King it is important to know that he actually studied there for one year only (1957/8) – and this as an independent student who did not follow the ordinary curriculum. He had a small room to himself and there he continued work in the figurative idiom but now of course becoming aware of Henry Moore's influence, represented by the Anthony Caro of that time, and also of the post-surrealist avant-garde, followed by Eduardo Paolozzi. Almost no pieces remain from this period nor is there any documentation of the following years 1959–60, when he began to teach at St Martin's and also to work as an assistant for Henry Moore at Much Hadham, because in autumn 1960 King destroyed nearly all the work which he had previously made.

The reason for this drastic action was his recognition of his own identity as a sculptor. After a long period of incubation, as it were, two incidents brought about decisive change. (10) In June 1960 he paid a visit to Documenta, the 2nd international exhibition at Kassel, and the American painting he saw there, notably the work of Pollock, Newman, Motherwell and de Kooning, showed him the immense gap which existed between their painting and contemporary modern sculpture. If this was a rather daunting episode his visit to Greece in that same summer provided a key to the future. On a Boise Travelling Scholarship he went back to the country from which the

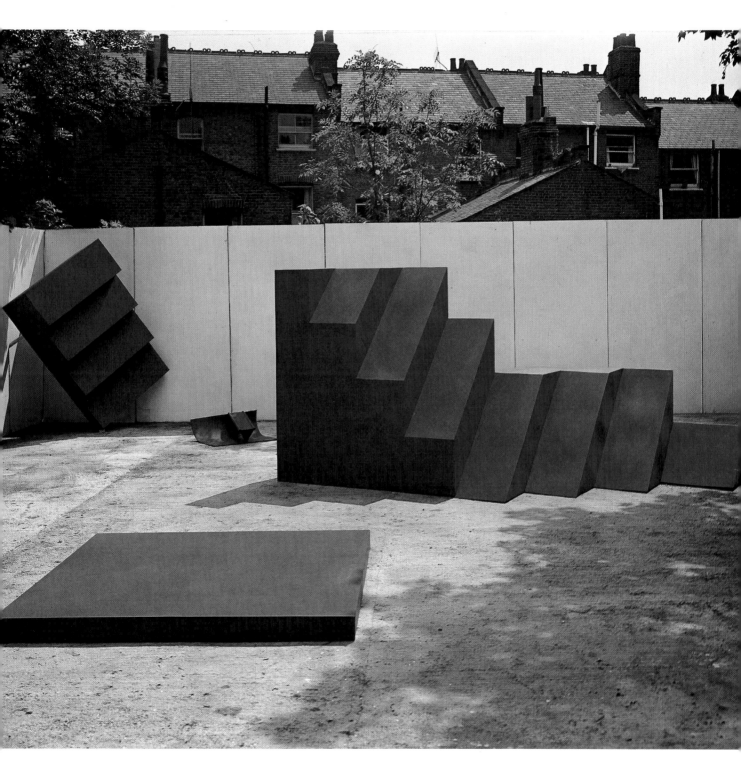

17 *Blue Blaze* 1969

European tradition of sculpture came – and there, at the source, so to speak, he realised that something essential had been lost in its subsequent evolution.

Years later, in 1968, he summarised the importance of this visit:

'Before 1960 I thought of abstract art as a bit too divorced from life. I was closer to Moore and the idea that a work had to be close to nature and to come out of a humanistic, pantheistic approach. Going to Greece made me consider the possibility of sculpture being natural and therefore of nature. It seemed to me that in Greece the architecture grew so naturally out of the environment, it wasn't something just plonked down like a formula, it had emerged out of the necessity of the people living there. It seemed of nature and not about nature, in a sense that it made me feel the possibility of starting on a fresh footing with something outside myself. It gave me roots, I suppose. The type of work I was doing before then was to an extent rootless in that it was all to do with *me*, not with the outside world.' (11)

In its highly personal phrasing this statement could be misleading. Because the one thing that Greek art and architecture does not do is to 'grow so naturally out of the environment'; if anything, it *confronts* nature. However this is not a real contradiction but turns out to be an explanation of what Phillip King means by 'naturalness', as his account to the Boise Foundation proves. In referring to the Parthenon he writes: 'This architecture in its own anti-nature way (in the Greek meaning of the word, rising in opposition or even opposite rather than against) seemed more involved with nature problems than most other forms of art at any other time.' (12) That is, the 'natural' quality of the Parthenon arises from a combative, or what the Greeks would have termed an 'agonal' relationship of man with nature.

The Greek temple is the clearest example. Not having an enclosed sanctuary like a Roman temple or a Christian church, it is open to surrounding nature and at the same time remains unmistakably separate. The same is true of its most important elements, the columns. Although they look less natural than, for example, an Egyptian papyrus column, they seem to stand more naturally, i.e. as a perfect embodiment of their function. The sense of their raising the roof they support is balanced by their task of bearing weight in a way which in its ease rivals nature. (13)

Once the architectural principle is grasped, as it certainly was by King, the origin of European sculpture is clarified. The earliest free-standing figures, the Greek *Kouroi* of the 6th century BC are constructed upon a severely geometric schema; and yet they emerge endowed with a power, a nearly explosive energy and vitality which has rarely been matched in sculpture. A mysterious contradiction, especially when compared with the 'naturalism' which followed. But if one turns round and, like Phillip King, follows the direction of the *Kourois'* ecstatic stare, it becomes apparent that these statues collect themselves, gather their strength, and step forward, as it were, in the face of nature. Later, when this confrontation vanishes, though the figures become more explicit as human images, they have lost their stance as sculpture – along with nature, their invisible counterpart.

So for King's understanding of the essential duality of sculptural presence the visit to Greece was of seminal importance. Yet there is no direct resemblance to Greek art in the work which immediately followed this visit, *Window Piece* and *Declaration*. He has never done an upright, let alone a 'statuesque', piece which aims at a similar confrontation. On the contrary, his work is characterised by a predilection for the horizontal and an emphasis on gravity.

The apparent inconsistency however is easily resolved. How could a modern sculptor assume a genuine Greek stance when the original reason, the opposing force of nature, is missing? Confrontation with nature is a concept which depends on the awareness of an overwhelming force both within and around the human being. As the German poet Hölderlin, an early hero of Phillip King's, has understood it, in his 'Comments on Antigone', the Greeks encountered a unique problem in being exposed to an abundant nature: they had to 'contain themselves' in the face of both an orgiastic spirit and an ecstatic appreciation of their surroundings. (14) On the other hand, the modern spirit is quite capable of 'finding its bearings', as Hölderlin continues, because there is pathetically little to be either clarified or contained, let alone any dangerous power of nature with which to contend.

The modern sculptor's problem, as King saw it, is virtually the reverse of the one which concerned the Greeks: first and foremost he has to find a reason for forming and shaping at all, avoiding the too quick flash of understanding which has become so habitual. In this sense, Phillip King's visit to Greece elucidated an earlier experience in Cambridge where he had been deeply impressed by Albert Camus' diagnosis that the disease of twentieth century man is a lack of any sense for the present. (15) The agility of our mind all too easily obscures the

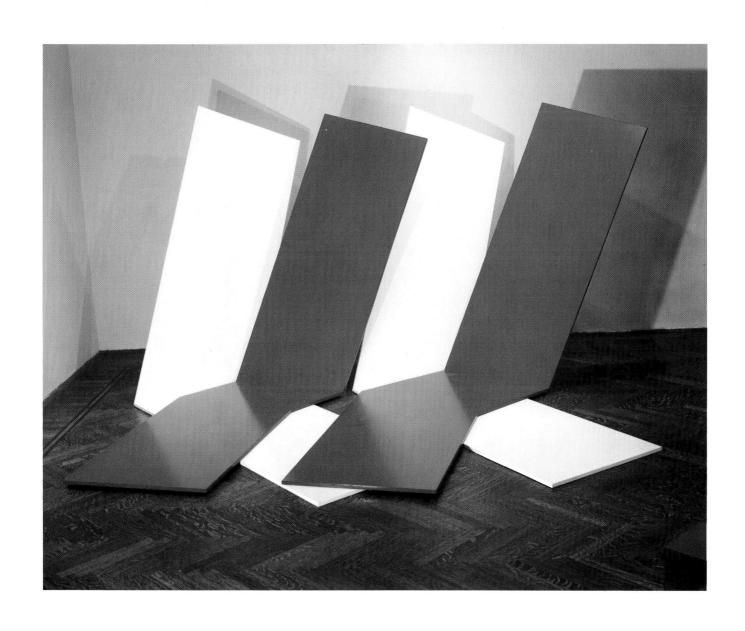

12 *Slit* 1970

fact that human existence in the twentieth century desperately lacks a footing, a style and a measure of life.

However far-reaching these reflections may seem, they led Phillip King to two important decisions. To begin with he abandoned the human figure because there no longer seemed any necessity to continue with this conventional theme of sculpture. It had become gratuitous, a mere image instead of a purposeful construction. Abstraction in King's oeuvre is not the result or outcome of a stylistic evolution but a consequence of the decision to plastically redress that deficiency which the traditional human image only served to camouflage. Obviously this does not mean that it was enough to simply replace the figure by an abstract object. The second much more difficult step was to develop a way of working which would embrace a seeming paradox: to arrive at a form of sculpture which, as a result reveals the very momentum prompting its construction.

The solution becomes clear in *Drift* 1961, and it is brought to a high point in two recent works, *Open Place* and *Bali*. Instead of imposing a structural concept King turns the basic act of assembling, accumulating, and putting the material together into a particular form of building. This is not just an experimental approach. In withholding any systematic organisation King differentiates on a fundamental level between human creation and nature's activity. Whereas nature grows, opens up, and evolves outwards, the human spirit, starting in the openness of nature, has to establish its existence by forming a basis first – and this not only in material terms. When someone makes a 'point' we instantly demand the foundation of his argument as well, being instinctively aware of our unavoidable fallibility as human beings in any art of making. The lack of natural roots turns the question of foundation into a primary issue. As Leibniz recognised, 'Nothing is without sufficient reason.' (16)

In this predicament Phillip King has found a form of expression which is a gesture, a shape and a symbol at the same time: the cone. It is a gesture of something *put down upon* and simultaneously *rising up from*; a shape which provides a single point with a wide basis and a symbol of man's creativity as opposed to nature's growth. King explained this duality of nature in a letter:

'I suppose the difference between a tree and a sculpture for me lies in the fact that one looks at a tree, feels its radiant energy, light all around it, and slowly one starts thinking back down into the tree and into the earth. With a sculpture it is the other way round. You start with a bit of earth, a lot of thinking and end up with a little light at the top. But the light is perhaps a little more tender, it is a more human light, my light, your light.' (17)

'The other way around', essential to man's activity, is manifested for King by the cone. Though with the Greek experience behind him he could not rest content with acknowledging this difference by simply placing a form with a pronounced gravitational pull such as the cone against nature's living force. The insight into this basic divergence only served as a starting point from which he could tackle the original issue: to make sculpture which in its own anti-natural way could call its opposite into being. In this context the emptiness of the cones which may have seemed puzzling initially reveals its full implications. *What is contained within is less important than what the shape displays.* As a negative form it draws to itself the lightness and openness of space; and due to its purely perceptual weight it assumes a relationship with the ground as though with a natural base.

The image of the cone, which reappears continuously in King's oeuvre, is far from a simple stylistic refrain. Each appearance reveals very different and even contradictory approaches. *Twilight* 1962 embodies a certain tender gesture, as though with fingers protectively outstretched one was delicately lowering something elusive to the ground. In *Rosebud* 1962 the tightly folded mantle of the cone seems to exert such a powerful pressure that it virtually bursts open. This tension between the sculptural 'grasp' and the invisible something which it tries to hold is further elaborated on a grand scale in *Genghis Khan* 1963. In the centre and at eye level, framed like an emblem, the tip of the cone points the limit of that which can be contained – whilst up above and below, spreading out and running across the ground, that which cannot be confined, the ungraspable, explodes and spills.

The cone pin-points the difference between form and shape in King's sculpture. It never figures as a self-sufficient geometric form because each particular version is developed in relation to the openness of space and responds to opposing forces. In this way the cone is shaped simply by context; and its contour is therefore not a separation between space and solid but a definition of inner and outer, of what can be contained and of what cannot.

In two subsequent pieces, *And the Birds began to sing* 1964 and *Through* 1965 Phillip King has polarised the ambivalence of this 'defining' using colour as a distinguishing agent. The exterior

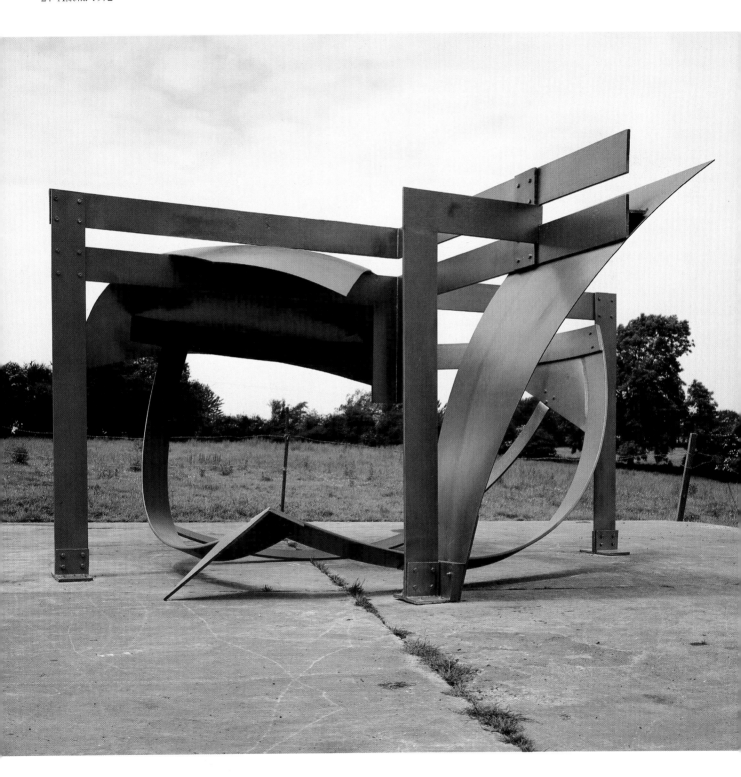

of the former, blackened as though oxidised through long exposure, opens up to disclose a brilliant orange cavity and a virtually infinite reproduction of itself. There is no core but only by implication another cone. Quite an alarming concept. But, as the title indicates, King turns this endless prospect into a jubilant triple-fugue. *Through* is a complementary piece in that the outer space cuts like a knife into the solid and so makes its structure. As a result, the sculpture doesn't appear as a cone with slices in it but rather arrives from the reverse understanding: the red cuts form the scaffolding between which the green slices 'congeal', as King describes it, into a shape. Matter and space have become convertible.

After 1965 the cone as such disappears until it returns in a very different sculptural context as *Sure Place* and *Open Place* (both 1976–7). But in understanding the basic role of the cone-*sensation* it is important to realise that the subsequent group of sculptures – *Slit, Slant, Brake* and *Nile* – are all directly connected with this sensation. *Slit* 1966 and *Slant* 1966 in particular can be read as a cone unfolded. Although divested of volumetric weight, the constituent L-shapes still evoke a comparable relationship between standing up and earthbound-ness. But the rhythmic acceleration of these elements already indicates a different sculptural problem as can be seen in *Brake* 1966 and *Nile* 1967. When the cone is opened up into space so rigourously the issue of confinement clearly has to be re-thought.

But whatever problems each appearance gives rise to, it is true to say that with the cones Phillip King declared his sculptural hand. He likes to call himself 'a modeller who constructs'. Firstly the cone expresses the characteristic modelling gesture, one which gently coaxes something into existence. In the second place, in order to freely allow something to *appear* instead of literally *materialising* it, King restricted this gesture to a subordinate role and consequently its nature changed. Although he may be a modeller in sensibility, the very nature of his artistic intention has turned Phillip King into a genuine builder: someone who constructs a framework to elicit and accommodate those invisible relationships basic to our existence.

3 *Dismembering the monolith*

In the development of King's work external stimuli are important to a surprising degree. Usually sculptors pride themselves on being engaged in a slow and sober task. But,

though it may earn the hallmark of respectability, this laborious aspect poses the greatest threat. More than any other form of art, sculpture tends to get stuck in the thicket of physical contingencies. And the satisfaction gained through heavy work easily obscures the fact that, just because of the material weight it carries, sculpture requires a great deal of mental agility in order to raise it to the level of art. When Phillip King became an art-student there was a tendency to regard sculpture, even at St Martin's, as something akin to a craft rather than fine art; and what changed this situation was not a sudden decision to work harder but the determination of a few people open to influences of all sorts to radically re-think sculpture. It was the exchange of ideas more than anything else which quite suddenly brought English sculpture to the fore-front of international attention.

In the first place however it should be stated that it was Anthony Caro's pertinent engagement which brought Phillip King to St Martin's at all. The natural competition which developed later between the two sculptors tends to overshadow the fact that Caro assumed for King the role of the one person so often needed in an artist's life to encourage a commitment. In the winter of 1956, when King walked into that art school 'next door' to Foyles, Caro was the first person whom he met and the first professional sculptor to whom he had talked in his life; the following year Caro came down to King's exhibition at Heffers Gallery, Cambridge (having received a first class return ticket with the invitation …) and in doing so sealed the initial contact; and later in 1959 Caro recommended him to Henry Moore as an assistant. Beyond this personal guidance a genuine artistic contact did not take place before 1960 when Caro, back from America, had begun his new work and Phillip King had returned from Greece.

Before that the situation at St Martin's could be characterised by a growing discontent with traditional principles and techniques, resulting in a few erratic experiments. Phillip King remembers as the most remarkable endeavours of that period such events as Eduardo Paolozzi building up a stock of legs and torsos in order to relate them disparately (as Rodin had done in *St John the Baptist*); Anthony Caro casting stone-forms as elements to be used in building up a figure (influenced by Dubuffet); and Tim Scott fabricating life-size hockey-players by pouring plaster directly into newspaper moulds. In 1960 however these probings acquired a new urgency. Although King did not join Caro's evening classes – having to run a class himself – his subsequent fibreglass and resin pieces were

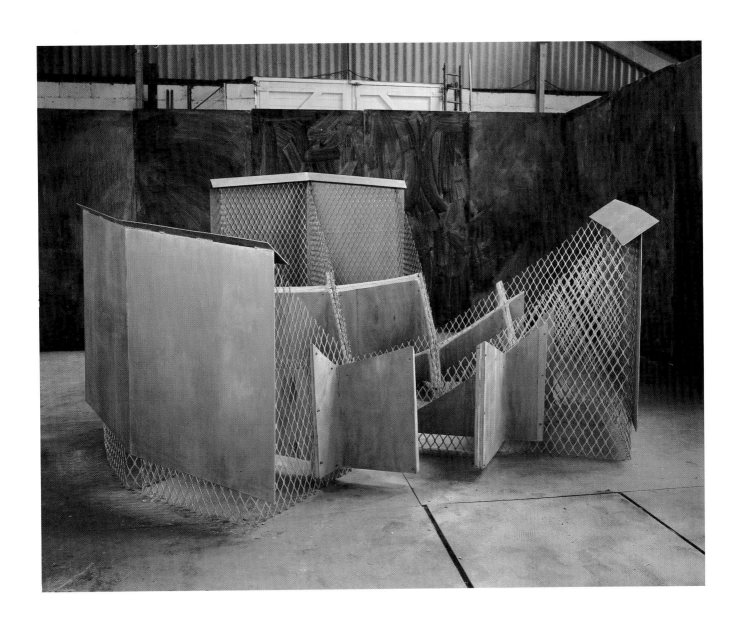

26 *Open Bound* 1973

certainly influenced by Clement Greenberg's advice to Caro, taken perhaps from Brancusi's notebooks: that sometimes one has to change the technique to do something afresh. (18) But more important were two ideas which Caro had assimilated from the American painters and which soon occupied all of St Martin's: the positivist ideal of aesthetics and the concept of non-composition. Jasper Johns is reported to have said to Caro: 'I want it to be like *that*' – with his hand outstretched, palm upwards.

At that time non-composition was not understood in the minimalist sense of simply 'positing' instead of composing. (19) It was deduced from Pollock's principle of being *in* the painting whilst working on it, thus defying a notorious academic practice – that of stepping back and surveying one's work as though making something was primarily a question of *adjustment*(20). Caro made his first metal pieces in a small garage which by its size literally prevented his stepping back at all. Though a rather imposed experiment it clarified the difference between making a thing and assessing an object, i.e. something conceptually 'fixed' before even coming into existence. An original piece, however, something which settles of its own accord, can only emerge when the sculptor is 'close up', going from decision to decision in a spontaneous rhythm of work. The abandoning of the pedestal, that much over-rated issue, is only a consequence of this direct approach. The involvement Caro propounded inevitably led to both the artist and his work standing equally upon the same piece of ground. The pedestal, that *post festum* prop, was only the accomplice of the preconceived object.

Non-composition was a liberating concept because by denouncing the stultifying aspect of 'composing' it left the way open for new and varied approaches. Although Phillip King did not adopt the spontaneous welding technique which Caro had instigated because he felt apprehensive about the associative logic involved ('one thing suggests another') he certainly agreed on the general principle. In a much later piece, *Sculpture '71* (Academy piece) he even provided the spectator with an experience similar to that of Anthony Caro in his garage. Pushed away by sheer quantity and excluded by a square block of Y and T-shapes which reach chest level, we cannot 'compose' this piece because the centre of raw and shining metal mesh is unapproachable. Thus we engage in an imaginary purposeful action, like a swimmer who is supported by the waves he cannot surmount. Originally however the concept of non-composition helped King to penetrate the am-

bivalence of 'construction'. In everyday parlance construction is generally understood as a systematic activity. But if a sculptor follows this line of thought he is soon trapped in the object-making attitude because he is drawn from the start towards treating his materials as composite parts. As Phillip King realised in *Drift* 1961 and two related sculptures (*Untitled 1 & 2*), construction is fundamentally an act of piling up, propping up – in short, of putting together individual elements; and the cone, his *leitmotiv*, is the quintessential expression of this understanding. It is a whole, a particular, yet total shape without parts.

This attitude of regarding the materials of his pieces not as merely subservient elements in an overriding whole but essentially as things in their own right has been a permanent stimulant for King's power of invention. In *Red Between* 1971, for instance, the liberation from hierarchic order is demonstrated by the three different groups of forms partly found as remnants of other pieces in his studio. The manner in which the rising verticals, the fluttering fins and the poles which pierce the petal shapes are joined together provokes through its frictions a powerful numinous presence which none of the elements alone nor any 'ordering' as such would have achieved.

The emphasis placed upon the discreetness of the parts links the concept of non-composition with the positivist ideal Jasper Johns had so strikingly stated. The belief that sculpture should be more like a thing than an image was originally held by William Tucker, and it has remained his credo ever since. (21) In his early piece *Tunnel* (1961), Tucker initially tried to attain this new thingness by equating his sculpture with objects of everyday use; and for a short period, to which *Window Piece* (1961) bears witness, Phillip King adopted a similar approach. Yet the respective choices of precisely which ordinary objects were to be selected as points of departure is significant because each reveals a very different concept of thingness. Whereas Tucker emphasises the concreteness invested in the shape of the things he used (two funnel forms), King instinctively found an object whose function is to appear not as an object at all. *Window Piece* articulates the paradox of a visual wall, the spectator being both barred from the space beyond and yet solicited to look through into it at the same time.

The implications of this early divergence have become much clearer since. There is a strong tendency in latter day St Martin's sculpture, intellectually supported by Tucker's theoretical writing and championed by Tim Scott's recent work, to reintroduce substantialism in sculpture under the guise of

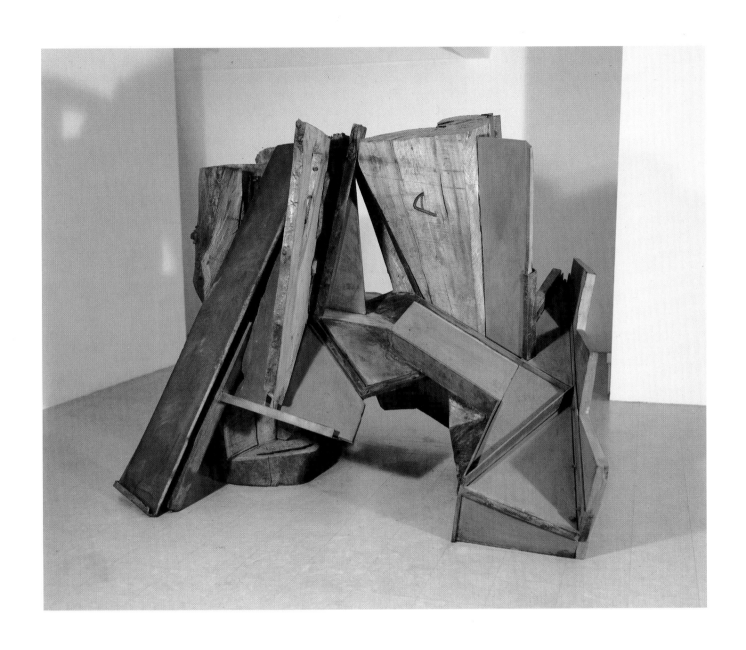

38 *Within* 1979

'thingness', albeit in a new form. (22) Phillip King, on the other hand, has resisted this temptation because he soon saw that the thingness of things does not reside in their actuality. For him the move towards everyday objects was only a springboard for discovering the importance of Brancusi; and again, it was not solidity as such which attracted him in Brancusi's work but the method through which such powerful presence had been achieved. Phillip King divined that Brancusi's much cherished solidity arose (paradoxically) from the multi-layered disassociated complexes which he built up.

Thus the concept of non-composition and the tendency towards thingness seems to converge. Sculpture is measure to the world of things when it is capable of re-enacting their essentially disparate character – as a principle of ordering. In terms of the tradition this may be a loss in symbolic stature. The resulting work will not represent a whole image of the world; but by being more *of* this world such sculpture gains a new directness of experience. In *Declaration* 1961 Phillip King has stated this premise in a forthright manner. Discs, squares and crosses are lined up symmetrically and joined by a pole which runs through their centres. Notwithstanding its dourness, *Declaration* announces the position from which every piece thereafter evolved.

The influence of Brancusi has remained a distinct streak in King's work. It is obvious in *Tra-la-la* 1963 where he converts Brancusi's way of stacking forms in broad flat divisions into a sequence of narrow acute points. The tip of the basic cone swells out into a slender spindle which, in turn, balances two thin tubes joined by a rope-like twist. *Barbarian Fruit* 1964 can be seen as a reversal of this same building principle. The sheer sensuality of layering is rhythmically emphasised. Carrying a pile of soft fleshy shapes, tiers of serrated forms rise from a sharply cut table. The units diminish as the upward movement accelerates and the doughy forms yield to a growing sensation of weight turning the entire accumulation back into itself.

Although this approach continues to be a dominant tendency in King's work, as *Ring Rock* 1976 makes clear, it was overshadowed in the late sixties by a notion which superficially appeared to summarise all that St Martin's stood for. The New English Sculpture, as it was internationally called, seemed to be concerned with abandoning, cutting-up or opening up 'the monolith'. The glib ideology even became vulgarized into an Oedipean reaction against Henry Moore, as though in the thirties the older sculptor had not himself already made ensembles of segregate pieces. (23) Indeed, one can anticipate that one day his reclining figures may be regarded, on purely stylistic terms, as 'forerunners' of so-called floor sculpture. More problematic though than these misreadings was the confusion caused amongst younger artists by propounding such a simplistic concept. Non-monolithic sculpture became the licence to gesticulate in a purely descriptive, or even worse, rhetorical manner with a skeletal syntax of steel in a blank vacuum called 'space'.

However, this should not detract from the viability of challenging the role of the monolith in sculpture. Perversion only arises when a practice directed against preconception turns into a concept itself. Without doubt Phillip King has done some of his best pieces, like *Slit* and *Slant* (both 1966), in trying 'to win over space', as he himself describes it; and with *Point X* 1965 he has successfully achieved an analytical 'cut-up' of the cone. Turning the pointed shape into a flat triangle, the round base into a circle and the ground upon which the cone stands into a square, he pushes this discursive language through mirroring and redoubling phrases, arriving at a dense and complex statement. But in pressing on with this 'opening-up' approach he was gradually being caught up unawares in a vicious circle: once the centripetal enclosure of the monolith is dissipated, it is inevitably recreated by the assumption of a containing *environment*.

The danger can already be intimated in *Slant*, a sculpture which seems to be on the point of sliding away. In *Brake* 1966 and *Nile* 1967 King made an attempt to counteract this tendency by turning back the current of movement to stem the flow. But in *Span* and *Blue Blaze* (both 1967) the problem is literally out in the open. *Span* could be interpreted as an abstracted sensation of being in a Greek temple. It describes a confined yet open place. Two upright blocks define verticality, two tipped planes denote gravity and a pair of squared pillars, each with base and capital, indicate ground and sheltering roof. But one feels a slight unease because the genius of the place lives only in the 'imaginary span' contributed by the spectator.

This feeling of an enigmatic habitat, waiting to be fulfilled by the spectator, is even more true of *Blue Blaze*. Each of the four parts serves a function commensurate with our physical being. A flat square asserts ground level, the largest of the components steps scale up irregularly in a sequence of diagonals, and a strange little 'foot piece', as King describes it, scimitar-shaped, makes the transition to a sort of upside-down displaced staircase, which stands on one point in the corner,

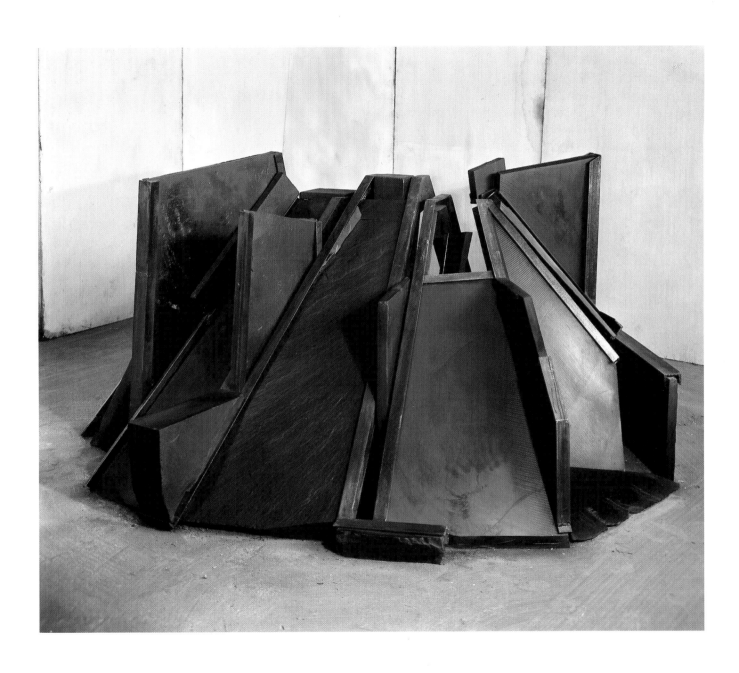

30 *Open Place* 1977

disclosing the necessity of a containing wall for the whole ensemble. In only just escaping the connotations of a stage set, it ambiguously borders on the precise meditative situation presented by a Japanese Zen garden. For the appeal to participate is eventually absorbed and stilled by an all-pervasive, hallucinatory colour, ultramarine blue, which envelopes both the spectator's inquiry and the sculptor's intention as well.

In *Blue Blaze* Phillip King had reached the limit. His innate sculptural sense for building as a putting-together was on the point of being replaced by a pre-supposed environment. Dismembering the monolith is a notion which can be sustained only in opposition to the monolith itself. When isolated and taken as an absolute, it shows itself to have no greater validity than the formalist reaction it may provoke: 'Why not reassemble the monolith?'

The true implications of dispensing with the self-sufficiency of the object and opening up the structure of sculpture are too fundamental to be masked by a simple formal strategy. They challenge a concept of *making* which is inherent in our civilisation and therefore permeates the human beings we have become. Far from being merely a sculptural notion, the monolith expresses man's intention to assert himself over the earth and take possession of it; and it should not be forgotten that this step was originally accompanied by the myth of a dismembered god (the earth being ploughed and turned into a man-made object). (24) Reversing this imposition by dismembering the monolith therefore demands much more than an open, discursive sculptural language can provide. It requires a complete reorientation of the attitude to making which has become prevalent in our cultures.

Although Phillip King had touched on this problem with the cone, connotations reminiscent of the monolith seem to have disturbed him. On the other hand he clearly intimated that the activity of cutting-up and dispersing shape had led to an erosion of his ground. At the critical point he had reached between 1968/69 he took two decisions which reveal the depth of his instinctive grasp of the issues he faced. Firstly he turned the entire argument inside-out by rejecting the monolithic concept altogether and instead substituted an overtly empty centre. *Reel* 1968 is a 'de-centred' sculpture which nevertheless retains the binding-together quality of the monolith and at the same time dispenses with any vestage of substance. Like Matisse's famous painting, it presents the essence of dance, exposing an ecstatic centre through the encircling rhythm of movement.

The second decision is more intimate. But it had far reaching effects on King's work in the seventies. Previously the pieces had been fabricated, due to their highly technical requirements, in various factories and workshops around London. In 1969 however he took a big shed on a farm near Dunstable with the intention of installing a completely self-sufficient workshop. It was not that nostalgic longing to 'get back into the act', so prevalent amongst artists at that time. Equipping himself with all the tools and gear he needed was for King much more like 'hole-ing up', so to speak. He embarked on a practice more conducive to the deeper understanding of what seemed to him to be the key to a new way of making – namely the ecstatic centre celebrated in *Reel*.

4 *A new sense of gathering*

Although the work of Phillip King in the seventies, particularly from 1975 onwards, looks remarkably different from that of the sixties the change is a result of a small though decisive shift in his intentions. The increasingly raw and sometimes even violent appearance should not mislead: it is still the cone which governs King's working sensibility. But by now, having been taken apart as an explicit shape, it has become a method of approach. Instead of proposing the cone as his basic conception – always more a symbol if not a talisman – he embarked on work according to its structural implications: with a lot of activity around an empty centre, aiming for that light at the top.

He approached the new situation with great circumspection and pertinency. On arrival he first made *Dunstable Reel*, a variation on that key piece *Reel*; and out of this came the significant body of work in the first half of the seventies, a whole series of open-centre sculptures. The new preoccupation is apparent in the loose gestural arching of *Quill* 1971, the hidden centre of *Sculpture '71* (Academy piece), and the dynamism revolving around the interior of *Ascona* 1971. Albeit transformed, the same theme can also be found in *Green Streamer* 1970 and *Angle Poise* 1973. Though *Green Streamer* centres on an eddying and whirling movement of flat planes, it is contained as a piece of sculpture by three peripheral accents: a vertical pole sliced in half which, as the tallest element, asserts stability; a curved double up-beat from the side which seems to trigger off the rhythm; and a flat triangular plane which dams and diverts the flow. In *Angle Poise* the permutation of peripheral structuring is carried even further. From two op-

posite corner-pieces extensions reach out and potentially connect in the middle. The disrupted span conveys a poised sensation which makes the missing transition the actual centre of the sculpture.

The summary of this period, a culmination and a transition at the same time, is *Open Bound* 1973, perhaps the most intricate piece of sculpture which Phillip King had made so far. In the way in which it sits broad-based on the ground we are immediately made aware that the invisible inhabitant of this place was the removed cone. But King has anticipated this response and placed by this large, empty shell a companion piece, an enigmatic strangely watchful guard. Though being clearly outside, this item could also be read as the displaced centre of the sculpture – who knows? *Open Bound* seems particularly receptive to a wide variety of projections; and yet it shakes them all off, gradually involving the spectator in the kind of *gathering* which went into the making of the piece. Most of its solid components are floating slightly above ground, set off by steel mesh which, like gauze, veils the whole. The mysterious centre reveals itself as the collective property of the highly diverse physical sensations which gravitate towards it. We are not so much aware of laminated wood, aluminium and steel mesh but more of a certain composite feeling arising from the soft yellow-orange blurr, a dull unpolished shine and a crystalline transparency, all coalescing in an airy, spiky fragility – in marked contrast to that dour iron element which accompanies it so stoutly.

The particular elusive quality of this presence must have surprised King himself, because only when he tried to develop this structure and 'coloured it up' in a second version, *Open (Red/Blue) Bound* 1974, does he seem to have discovered the implications of what he had done. Despite their physical fabric the materials in *Open Bound* operate in an insubstantial way within the context of the piece as genuine sculptural equivalents to *colour* in painting. This insight opened up a new dimension in King's work. In the second half of the seventies he developed a rich palette exploiting the *valeurs* of materials. First of all there was the wide spectrum of steel, ranging from light-reflecting silver through an orange bloom to a dark oily black. Then, in 1975, he discovered the subdued irridescence of slate, encompassing infinite shades from strong cobalt blue to deep purple, each cloaked in grey. And finally, having always admired Brancusi's wooden sculptures, he took advantage of the ochre tones offered by wood which run between green and fugitive red.

So the re-orientation of his working approach had a surprising result because, in getting round the cone, so to speak, Phillip King did not produce a new form as such – but instead a new sculptural use of colour. Previously he had *applied* colour as a means of characterisation. It served the function of assisting in the transformation of a physical reality into a purely plastic appearance by either emphasising, differentiating or contradicting. The deep purple-blue in *Genghis Khan* announces the grandeur of the presence, and similarly, the wine dark shade of *Red Between* echoes its primeval density. The more frequent use of colour, however, was that of identifying and reversing formal functions. In *Slit*, for instance, the red and white polarity establishes a symmetry and a counterpoint at the same time. The very fact that the white panels underlie the red ones lifts the whole piece in defiance of gravity. In *Tra-la-la* King has pushed this principle to the utmost refinement. The actual colour, a pale tinted grey, seems to flow upwards accompanying the formal structure from mauve *via* blue to pink, whilst the surface quality of the paint unexpectedly reverses this sequence by descending from a matt dullness at the top to a glossy shining base.

During the period when Phillip King became involved in the dismembering of the monolith colour simply took on the role of an accomplice. The actual dismembering process is made visible through the agency of colour changes. In *Point X* what was virtually the starting point, a solid cone with a continuous surface, is evoked by colouring all the planes chocolate brown and choosing a bright lime green for the contours as though the original cone had been chocolate inside and lime out. A similar device was used in *Through*. There an overriding green indicates an intact condition whilst red articulates the cuts and incisions. Thus colour was increasingly restricted to the function of tracing the sculptural argument; and not before this direction had reached its final apogee in *Blue Blaze* did colour regain its power, as a 'life-line into this invisible world where feeling takes over from thinking'. (25). But *Blue Blaze* was a late flowering and, all-enveloping though its presence was, it did not indicate a move forward. The re-orientation of his working methods around the empty centre had inevitably prised colour away from its earlier position, the surface of the cone, upon which it depended to render the actual shape insubstantial.

It is worth recalling this earlier use of colour as such because it shows that King always had a strong colour awareness concerning his materials. One would therefore be grossly mistaken

if one regarded the colour in his recent pieces as merely a Romantic response to the colour of natural substances. He employs these materials in a way analogous to the use that a painter makes of pigments because he doesn't treat them as specific things but as distinctions of matter in general. Usually matter is defined simply in relation to form, as a material *for something* – but not as anything in itself. (26) So, for instance, the earth is the material *for* the form of the tree, the tree the material *for* the form of timber, timber the material *for* the carpenter etc. But when this bias towards intention is suspended, as in the work which King did in Dunstable, the original condition of matter itself becomes apparent. Though it is still characterised by its *suitability for ...* the potential, now liberated from the purpose of 'forming', shows itself to be a spectrum of properties rather than a group of qualities. 'Matter' is rough, fine, hard or gritty; light, heavy, crisp or soft; shining, dull, drab or tinted – and it is all of these, and many more, without being necessarily either wood, steel, slate or mesh.

Initially this approach could seem almost obtuse but gradually King achieved the subtlety and sophistication necessary to prove his point. Amongst his recent pieces *Within* 1979 is perhaps the most eloquent. It may in fact consist of crude elm wood, steel and slate but it does not present a mere assemblage of these materials. Instead different characters seem to come forward, retreat, conflict and combine as we move around the sculpture. On one side a bold, almost muscular congestion of massive chunks, tightly jammed together, towers up, throwing off an ochre pallor. This aspect could be seen as a highly expressive posture in itself were it not acting also as both a support and a foil for an event of very different character on the other side of the piece. There a sequence of planes, partly faceted, climbs and twists, reminiscent of cubist painting both in its hermetice passaging and in its low-pitched colour modulation. Although more fastidious and circumspect, this movement rivals its counterpart in complexity by the introduction of another note: cold, sharp, ominously withdrawn within dark and shadowy greys. Strangely, the description of this work involuntarily evokes the impression of an open-centred sculpture. But the reverse is true. *Within* is densely centred: parts are leaning-in, laid-in, bolted-in and wedged-in. Obviously between *Open Bound* and *Within* a profound change brought about by the new intimacy with materials as matter had taken place in King's understanding of structure.

'I have tried to see raw materials', he wrote in 1973, 'as something free of associations, having a high physical resistance but a low mental one, being essentially pileable, stackable, cuttable, etc.' (27) Suspending the objective of form does not mean surrendering to the suggestion of material; on the contrary, the more freely the mind avails itself of matter's potential, the harder the physical resistance is felt. Once the challenge of this duality has been accepted *making* takes on a new significance. Every cut, so to speak, is simultaneously a way of piercing physical complexity and a cleavage through the miasma of options; and conversely, piling and stacking becomes essentially an act of decision – of making up one's mind. It is a delicate correspondence of opposites which, though never really merging, seems to converge when the inner life of the mind impinges on the external domain of reality.

Having resolved this into his 'routine of obsession' Phillip King was able to relinquish the literalness of open-centred sculpture in favour of a ubiquitous presence. And so the last trace of formalist logic vanished. Form became synonymous with the *putting together* and *standing* of a sculpture, as clearly stated in *Open Place* 1977. Although related to the earlier cones and also to *Open Bound*, it assumes a very different identity due to the fact that its construction and its sculptural conception are virtually one and the same. On the outside a scaffolding of rusty metal seems to encase and support a sequence of large sloping slates – but from inside, this structure can also be regarded as a sort of break-water holding back a dark and pressing weight. Similarly the three slabs which intersect the grey plane appear to jutt-out and to prop-up simultaneously. Thus a highly complex sensation results from the simple device of *placing* – by transversing, slanting and turning inwards.

Working without a particular material and formal concept gave Phillip King a new fluidity of invention. He could re-phrase the method of assembling used in *Open Place*, for instance, by leaning steel sheets, predominantly curved, against one another and so arrive at a remarkably different piece – *Bali* 1977. Moreover, ideas which one might have thought superseded flowed back into his work. The first authoritative work of this period, *Sculpture '74*, is in fact a distant relative of *Tra-la-la*. A great block stands up boldly, almost like a monolith; around it clings a heavy trellis which unwinds sideways to display a huge open triangle which, in turn, holds out a small vacant rectangle. Although the pointed, threefold structure is reminiscent of *Tra-la-la*, the spirit invoked has changed considerably. There is a growing sense for the raw and wild in King's recent work, a genuine chthonic phantasy seems to

reverberate throughout. The concrete block in *Sculpture '74*, though undoubtedly the most solid element, appears surprisingly as a soft, almost organic outcrop of natural stone in relation to that downward thrust which only just seems to have missed it; and yet, the light which glitters in the rusty mesh turns this aggressive wedge into something like a mirage. No further clue is offered, apart perhaps from that small box at the extremity which brings the whole astounding apparition somewhere within human reach.

The *combattimento* of dissonant sculptural characters in King's work has been steadily gathering momentum ever since. Nameless as these forces seem their echo might easily be dismissed as a phantasmagoric delusion. However, in a small piece called *Tracer* 1977 Phillip King has almost playfully disclosed the stringent a-logic involved. Though appearing to joyfully rock about, the whole assemblage of slate and steel is tensely bound together; and indeed, a steel rope intricately strung seems to be the main constructive factor. From its anchorage in a metal drum this rope loops purposefully through the back-bone of the piece as if to heave up the weight below which, in turn, appears to pull the rope itself out onto a broadly spreading apron. But just at the point where one would expect in all likelihood this rope to be firmly fixed – it simply hangs loose. By upsetting the logical connection King establishes an open equation of self-regulating forces which allow each element of the sculpture to play its own part.

However lightly displayed this structural principle informs the powerful presence of King's most recent sculptures. In spite of dense configuration they are without governing axis or central core. *Shiva's Rings* 1978, though apparently wound around in simple manner, is essentially a piece about finding the point of repose within a rolling movement; and *Ring Rock* 1979 conveys the floating sensation of a table which, although loaded, ambiguously rests upon the very weight it carries. It could be said that this suspension of functional expediency is already foreshadowed in the broken ground plane of *Red Between*, or even of *Through*; but only in the work of the last two years does this device develop into a significant motif. It accommodates the heart-beat, the immaterial pulse, which calls these pieces forth into their mythic being.

At last the complex realisation of *Within* 1979, *L'ogivale* and *Shogun* (both 1980) allows an identification, however provisional, of that primeval spirit which had increasingly infiltrated King's work. *Shogun* is a relatively explicit piece. As opposed to the prevalence of curve formations in King's oeuvre, it is unmistakably four-sided: a kind of ceremonial container, built around a body of wooden hunks which are supported by an open irregular fretwork of steel. The wood and steel form a narrow cavity into which is jammed a chain, both supporting and being supported. Each aspect of the sculpture presents a different 'face': at the prow a winged standard, at the bow a huge clamped-in pole projecting a giant eye. On one flank the piece seems to be heavily armoured in sheets of steel, whilst on the other a long yellowish pole, thrust diagonally downwards like a kind of archetypal plough, brakes and arrests the sledge-like carriage of the whole. The entire sensation is unmistakably archaic: earthy and violent, elementally laborious and of solemn grandeur. But it is by no means primitive or atavistic; indeed, the very opposite is true.

Undeniably, the spirit which Phillip King raises is the spirit of the Earth. Yet the impeccable a-logic of his approach safeguards the work from acquiring a Gorgonian or Herculean presence. Phillip King has no tragic relationship with nature. The grapevine of Dionysius is neither cut nor pruned back in order to provoke the Earth. (28) On the contrary, once the monolith had been abandoned, he set out to reassemble the dismembered body of that anonymous entity called 'matter': grafting sophisticated edifices which could endow this degraded 'stuff' with a new spiritual life. King once said about Matisse and his paper cut-outs: 'He is the gardener'. (29) Well, his own endeavour could be described in a similar way. Phillip King is *the builder*, an authentic descendant of Dedalus. However, being exposed to the desert which, as Nietzsche predicted, is steadily encroaching, he builds places – even labyrinths – which, unlike those of his mythical ancestor, *invoke* the power of the Minotaur instead of hiding it away.

The wild, perhaps even disturbing, vitality of his achievement should not be confused with the premise of his work. Again, in accordance to the insight which made Phillip King into a sculptor – the dual nature of presence – the spirit of the Earth is congenial to a highly lucid and gentle mind:

'Here I am, my material is there. I am in my body, with my height, my weight, my reach, my eyes looking out. I have the feel of looking out. The material also has weight, a certain malleability, it can be built from the ground, the same ground on which I stand ... I am the onlooker, the agent for the material to build itself up. In my mind I am not going to make a construction, that would be a negative preconception. I act and react. I make it like I might make a table or a chair, but there are no rules to follow ... From

nothing something happens. I begin to feel better when looking at the work. I begin to feel lighter on my feet. It is as if I am breathing more easily. If *I* can make it visible, *it* will occupy a position and then I will also find a place. Becoming visible the thing takes on an identity, like dogginess is dog … The thing is growing within its own laws determined by our mutual relationship, my physical make-up against its physical make-up. Not a metaphor for something, but an identity been revealed. From that original nothingness something totally unexpected has grown and reveals itself as something strange and yet familiar. It feels rather like coming across a new species: completely adapted – and yet a new thing in the world.' (30)

Notes

1 *Phillip King*. Exhibition catalogue of the Kröller-Müller Museum, Otterlo (Netherlands), 1974, p10. This catalogue (subsequently referred to as Kröller-Müller cat.) contains an almost complete collection of Phillip King's notes and writings before 1974.

2 Ibid, p9

3 Ibid, p19

4 Ibid, p27

5 The difference between 'thingness' and 'objectness' has been a central theme of the philosophy of Martin Heidegger. Although his argument is very complex on an ontological and historical level, the main point can be elucidated in simple terms. Heidegger proves through close interpretation that Western philosophy has persistently omitted a fundamental problem by understanding 'being' as 'being *present*' – without ever questioning the *meaning of presence*. Thus in the 17th century the notion of 'things as objects' could emerge and acquire, with the help of the sciences, a nearly impenetrable evidence. 'Object' is virtually everything which comes to our awareness through the *act of representation* – the empirical tree as well as the abstract idea of it. But this is neither an absolute nor even a sufficient concept. 'Objectness' is in fact a derivative version of 'thingness'. In turning something into an object of attention we already rely upon a primary accessability of things as such. Heidegger calls this fundamental condition in which the world avails itself without prompting: 'being *absently present*'. Although a paradox in logical terms, the existence of such a state is quite common to everyday experience. *Missing* someone, for instance, can be a relationship which endows the person missed with a powerful, nearly overwhelming *presence*. In a similar way the realm of things is disclosed to us: things are positively *given*, long before we pick up on them; yet the way they avail themselves is, to *elude* us. Obviously Phillip King's insight into the 'dual nature of presence' is based on this fundamental ambivalence, and it is by no means an illegitimate association when William Tucker's writings pay tribute to a philosopher whose late work culminates in the one question never asked by European metaphysics: what is a 'thing'? (cf M Heidegger, *Das Ding*, 1950, in *Vorträge und Aufsätze*, Teil III, Pfullingen 1954, p37–55)

6 The connection between the Shintoist concept of nature and the particular version of Buddhist temple architecture in Japan has been pointed out by Dietrich Seckel, *Buddhistische Kunst Ostasiens*, Stuttgart, 1957, p44–85.

7 Phillip King, inaugural talk at the Hochschule der Künste Berlin, summer 1979 (unpublished tape)

8 Cf Joachim Gasquet, *Cézanne*, Paris 1921. After having been introduced in the chapter on *Le motif*, the theme 'colour is the place, where our mind and the universe meet' is repeated in many variations throughout these semi-fictional 'Talks with Cézanne' (see the second part: *Ce qu'il m'a dit*).

9 Cf *Questions to Stella and Judd*. Interview by Bruce Glaser, ed. by Lucy R Lippard (*Art News*, September 1966). Reprinted in Gregory Battock, *Minimal Art. A critical anthology*, London 1969, p148–164

10 'Phillip King talks about his sculpture', *Studio International*, June 1968. Reprinted in Kröller-Müller catalogue, p34–37

11 Ibid

12 'Trip to Greece', official report to the Boise Foundation (1960). Published in Kröller-Müller catalogue, p13

13 See Ludwig Curtius, *Die Antike Kunst*, Zweiter Teil: *Die Klassische Kunst Griechenlands*, Konstanz 1938, p114–116 for a discussion of the distinction between the Egyptian column and the Doric column as the 'symbol of the Greek spirit'.

14 Cf Friedrich Hölderlin, *Anmerkungen zur Antigonae* (c 1795–1800) in *Sämtliche Werke*, Bd 5, Stuttgart 1954, p289–296. My paraphrase summarises the meaning of an intricate sentence on page 294 which reads in literal translation: 'The Greek conceptions change insofar, as it is their main tendency to contain themselves because this was their weakness, whereas the main tendency in the conceptions of our time is the ability to hit something, to exert facility, because the fateless ... is our deficiency'.

15 Cf Albert Camus, *L'homme revolté*, Paris 1951. In relation to King's contention that modern man has lost his 'sense for the present', the last chapter, entitled *Mediterranean Thinking* is of special importance. There Camus asserts that the revolt *is* measure and style in defiance of totalitarian ideologies and the notorious escapism opting out for a better though nebulous future.

16 The logical principle that 'nothing is without reason' (*nihil es sine ratione*) has been pronounced for the first time in its full meaning by Leibniz in paragraph 32 of his famous *Monadologie*, 1714 as the necessity to accredit everything with a sufficient basis (*principium reddendae rationis sufficientis*). The curious historical delay of this insight and the enigmatic paradox involved – that this principle is *basically* about 'raising a point' – has been interpreted by Martin Heidegger in a series of lectures held at Freiburg University in 1955/6 and published immediately afterwards under the identical title: *Der Satz vom Grund*. Pfullingen 1957.

17 'Letter to Richard Matz' (a Swedish philosopher) concerning the alienation of man in his world today. Published in Kröller-Müller catalogue, p39–41

18 The crucial role direct stone-carving (la taille directe); as opposed to working with the pointing machine, played in Brancusi's liberation from Rodin's overwhelming influence has been discussed by Sidney Geist in his study *Brancusi/The Kiss*, New York/Toronto 1978, p2–9

19 In the sixties the concept of non-composition became contaminated with the so-called non-relational approach (see the contributions of Robert Morris, John Perreault and Barbara Rose in Gregory Battcock's anthology *Minimal Art*). Composition was simply replaced by the 'wholistic' proposition of uniform objects. Thus the original issue, the artist's relation *to* the work being made became obscured by a conceptual speculation on the formal relationships *within* the final work; and as a result the preconceived object – the very assumption against which the earlier practice of non-composition was directed – was candidly re-instated.

20 The problem was of course recognised long before the actual concept of non-composition was formulated. The battle against 'composition as adjustment' has been an important factor in the evolution of modern painting. The *plein air* practice of the Impressionists, for instance, was originally much rather an attempt at working directly 'on the motif' (as opposed to the academic device of 'garnishing' formal prototypes) than a method of catching fugitive effects. The way in which Monet worked on the *Nymphéas*, close up, yet in full command of his vision, already foreshadows Pollock's approach of being *in* the painting.

21 Cf William Tucker, 'What Sculpture Is', lecture series at St Martin's School of Art, 1976

22 Cf Tim Scott, 'Interview with Erich Franz and Michael Pauseback' in *Tim Scott, Skulpturen 1961–1979*, exhibition catalogue of the Kunsthalle Bielefeld, 1979, p10–39. The following argument seems to be characteristic of Scott's present position: 'Caro in particular worked and still works in a way that has not very much to do with the *nature* of steel. It has to do with what you can *do* with steel, but less to do with its nature. What I found interesting about forging was that it seemed to me to have to do with the very *nature* of the material itself' p34. Although the validity of such an attitude is beyond doubt, it should be pointed out that emphasising the *nature* of steel is only another way of *doing* something with it, namely to substantialise it.

23 Amongst Moore's sculptures of the mid-thirties the 'dismembering' tendency is particularly obvious in *Composition*, 1933; *Three piece carving*, 1934; *Four piece composition: reclining figure*, 1934, (collection Martha Jackson); and *Four forms*, 1936 (Collection Henry R Hope).

24 The convergence of the myth of the dismembered god with the beginnings of agriculture has been explored by Adolf E Jensen, *Die getötete Gottheit*. Weltbild einer frühen Kultur,1966 (Urban-Bücher 90).

25 Statement for 'Colour in Sculpture', *Studio International*, January 1969. Reprinted in Kröller-Müller catalogue, p37

26 Aristotle, who introduced this schema, leaves no doubt that matter and form are *relative* distinctions. Moreover, he invests the Greek word for 'wood' (*hyle*) with the abstract meaning of 'matter' – thus indicating that wood (and not clay) is *the* quintessential material: it ambiguously rests between matter and form.

27 'Letter to Richard Matz'. Published in Kröller-Müller catalogue, p39–41.

28 An entire essay could be written on the role Rilke's *Ninth Duino Elegy* (his poetic theory of art) played in the process of clarifying the aims and ambitions of the New English Sculpture. Cf Rainer Maria Rilke, *Duino Elegies* (1922). English translation with an introduction and commentary by J B Leishman and Stephen Spender, 2nd ed, London 1977. Whilst Tucker seems to have recognised his own intentions in a line at the beginning of the *Ninth Elegy* ('Are we, perhaps, *here* just for saying: House, Bridge, Fountain, Gate, Jug ...'), Phillip King has referred in a recent lecture to part of the middle section (see note 30). There the poet exhorts the artist to call upon the 'angel' as the archetypal mediator of human ambitions: 'Show him how happy a thing can be, how guileless and ours; how even the moaning and grief purely determines on form, serves as a thing, or dies into a thing ...' Yet in looking at King's most recent work I feel that beyond this indirect self-interpretation, he now provides a clarification of the mysterious end of the poem: 'Earth, is it not just this what you want: to arise invisibly in us? Is not your dream to be invisible one day? Earth! invisible!

29 Kröller-Müller catalogue, p9

30 'Sculpture and creativity and meditation', talk at Mentmore Towers, November 1979, p2 (typescript)

Works in the exhibition LYNNE COOKE

The footnote numbers refer to the 14 texts cited by Lynne Cooke (listed at end). The measurements are in centimetres, height × width × depth.

1

Window piece 1960–61
plaster 173 × 122 × 38
Rowan Gallery, London

Window piece marked a substantial break from King's earlier sculptures such as *Flower Woman*. It was executed soon after his return from a trip to Greece in the autumn of 1960. This visit formed a hiatus in his career since it was largely responsible for persuading him that abstraction could be a viable idiom for contemporary sculpture. From Greek architecture he gained the conviction that, contrary to his former beliefs, abstract art was not 'too divorced from life'. With their carefully tempered proportions, these temples had an animate character that was 'of nature but not about nature', they were more akin to its fundamental forms or processes than to its appearances. To that extent they were quintessentially natural in a manner which was impossible with figurative representation. Intrinsic to this art was its verticality; the building stood upright in man's space clearly distinguished from the earth below. Greek architecture thus provided a paradigm for an art that was man-made and uncompromisingly abstract, without being alienated from nature.

Following King's return to London he executed numerous drawings in search of a way to realise his new convictions. Above all, it was the objecthood of sculpture that he wanted to assert, its bare factual existence, immutably present and non-illusionistic. The simple lucid objects like doors, windows, ladders and boxes found in these drawings seemed to offer the requisite sense of presence and of palpable, physical existence that he now demanded as a keystone of sculpture.

The experience of Greek architecture released King from his previous mode of improvisatory experimentation in favour of a language of lucid architectonic forms, first seen in *Window piece* then, more assuredly, in *Declaration*, made early in 1961. Although still using malleable materials like plaster and concrete, as in *Flower Woman*, King's manner of handling the matter changed radically. He no longer manipulated it into a personalised handwriting but through the smooth matt surfaces allowed the clarity and anonymity of form to prevail.

In *Window piece* King establishes a new directness of interchange between viewer and sculptor. It demands to be seen at close quarters: 'it was something to see through'. The space in which it exists is real space, for *Window piece* stands directly on the ground in the observer's space and is not removed to an ideal (or abstract) space by the intermediary of a pedestal. (However, in the present exhibition, its first public showing, King decided that the extensive surrounding space of the Hayward Gallery required something to make the transition between the plaster and the floor.)

In the drawings, as in the sculpture, King minimised problems of composition making the image as straightforward as possible: there are no complicated mechanisms and no deceptive techniques, any more than in Greek architecture where the basic post and lintel system of construction sufficed for all needs. As in these prototypes, so in *Window piece* and *Declaration* the surfaces and edges have been carefully adjusted to heighten the visual impact and the legibility:

> The problems of the Greek architect, it struck me, were more with making an object stand up, or a straight line appear straight . . . than with an intellectual harmonising of forms. First as always, came the eye, the stone, the viewer, the object, then the mental combination of forms. (5)

The window image brought a heightened immediacy at the same time as it was non-associative, for it was no more than it appeared to be. Yet for all its factual directness King felt that the sculpture was still too image dominated; he wanted to retain its object quality without the sense of 'thingness' attendant on an identifiable form. This was achieved in the abstract *Declaration*, King's first fully mature work.

Phillip King
Flower Woman 1959

1

2
Declaration 1961
cement and marble chippings 84 × 208 × 84
Collection of the artist

Original in the collection of the Leicestershire Education
Authority

'*Declaration* was a sort of manifesto piece for me', King said of this
work which creates a watershed in his career. Its indisputably abstract
nature, open yet monolithic form, and compositional method make
it a cardinal work: the first realisation of newly-won aesthetic. King
has threaded the various elements along a metal bar so that they stand
directly on the ground in symmetrical array. Given its height of
thirty-three inches, the sculpture cannot be viewed directly from
above but must be seen obliquely. This fact, together with its sym-
metry and length of roughly seven feet, means that it can be en-
compassed within a single glance. Thus the sculpture is perceived as
a single entity, a cubic form rather than an additive sequence of
separate elements. Partly on account of his reading of gestalt psy-
chology King was very concerned that his works should have a total
image, that they should be read as a whole, a single object. *Declaration*
is monolithic in overall configuration although it is not a closed
volume.

Its abstract non-associative character largely depends on the ele-
ments employed: squares, circles and crosses. An obvious precedent
for this use of geometric forms devoid of allusion is *Twenty-Four Hours*
(1960), Anthony Caro's first abstract sculpture and a talismatic work
for those younger sculptors, including King, gathered around him at
St Martin's School of Art. Yet the differences between the two sculp-
tures are substantial. At this time King eschewed welding as an
unnatural technique since it allowed the artist to deploy his com-
ponents in direct defiance of the dictates of gravity. Such procedures,
and cubism in general, contradicted King's ideal of a natural form of
sculpture. For that reason he preferred the monolithic tradition of
sculpture, in which he felt Brancusi was paramount.

King's choice in *Declaration* of abstract forms devoid of personal
imprint was designed to allow clear expression of the basic idea, to
prevent it becoming loaded with allusion. Since he regarded the idiom
of subjective expressionism prevailing in much post-war sculpture as
clichéd and moribund, wholly inappropriate to contemporary ex-
perience, he turned to first principles and to the pioneers of early
twentieth century sculpture in his search for a more valid sculptural
language. King had seen a small retrospective of Brancusi's work at
Documenta II in Kassel in 1959 in the midst of what he regarded as
a depressing array of contemporary sculpture. He recalls being im-
pressed by the Romanian's mode of composing in direct harmony
with the dictates of gravity; stacking, aligning and abutting forms
together. The simple mode of composing in *Declaration* attests to this
impact.

3
Drift 1961
painted cement and wood 152 × 117 × 36
Anthony Caro

Edition of three:
Anthony Caro, London
Private collection, London
Rowan Gallery, London

A tendency to equate the natural with the organic may have
contributed to King's move away from the pure geometric forms of
Declaration to the biomorphic shapes of *Drift*. Impetus to this way of
thinking perhaps came from abstract surrealism in general and from
Arp in particular. But while Arp's lyrical objects tend to nestle
comfortably on the ground like animate beings, King avoided such
a romantic aura in favour of a more vigorous image, one which
surprises rather than lulls the sensibility. In *Drift* the pendulous 'drip'
of concrete seems poised but momentarily as the wooden frame braces
itself to withstand the massive weight: strong tension rather than an
easy balance binds the components. In 1979, in response to an enquiry
about the influence of Brancusi on his work, King stated:

> . . . the power of Brancusi was in the stacking principle . . .
> The way out for me was not . . . to stack in yet a simpler way
> but to use other principles that were equally powerful but had
> not been used by Brancusi. Matter and standingupness being
> recognised by me at the time as the first basic relation in all
> sculpture and especially in Brancusi. It seemed that another
> way . . . [of] standingupness and that wasn't using the stacking
> principle would be leaning up or propping one thing against
> another to make it stand up. (10)

Colours have been determined by the materials, although King en-
hanced their natural qualities by staining the wood and whitewashing
the plaster. Certain aspects of the form may feel familiar but the
overall image is not, for *Drift* revitalises a given formal language by
means of an unexpected mode of composing. Contrasts of texture,
colour and shape complicate the internal relationships so the image no
longer operates primarily in that realm of poetic association conjured
up by Arp. These relationships require a careful scrutiny which in turn
affirms the physical immediacy and presence of the sculpture.

Perhaps finding that biomorphic shapes were too personal, King
did not continue in this direction since he was seeking a way for his
art to have sources outside himself, in something more fundamental:

> The experience of Greek architecture . . . made me feel the
> possibility of starting on a fresh footing, with something
> outside myself . . . as if one could have a more permanent
> approach to art . . . it gave me roots, I suppose. (4)

On the sheet of paper on which *Rosebud* (1962), an elemental cone
shape, was first sketched King indicated his dissatisfaction with the
direction taken in *Drift*:

I must get away from the arbitrary choice of a loaded shape – shape must appeal for an intellectual reason that must be involved with a total outlook. Not an emotional demand tempered by consideration for the intellect. I must say to myself, I believe this or that, and from these precepts the idea will come. (5)

This statement is important in identifying the crucial role played by theoretical concerns in King's approach to sculpture: articulated premises underlie the imaginative realisation.

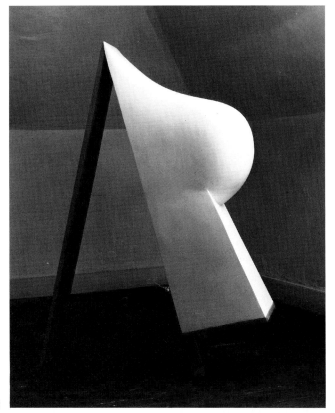

3

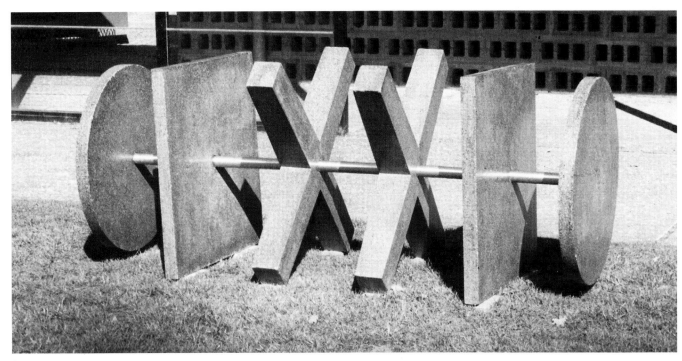

2

4
Rosebud 1962
plastic 152 × 183 × 183
Collection of the artist

Original in the Museum of Modern Art, New York

Rosebud is a pivotal work, a display of cheeky originality imbued with a new level of wit and exuberance. Its playful mood may be partially indebted to the 'new note of hope and optimism' which King admired in the recent American painting he saw at Documenta II in 1959 and found so lacking in contemporary sculpture. With its cool pink sheath covering a delicate green lining, *Rosebud* has a daring that becomes a hallmark of King's best work. As he said:

> I want people to stand aghast for a second, and I hope they'll do it again and again with my best work. (1)

In *Rosebud* colour has become an important ingredient for the first time. King used colour to various ends, not least to infuse the sculpture with a particular identity, to give it character. Although there were immediate precedents for the use of colour in sculpture in Caro's work, the vibrancy of this particular combination and its sheer unexpectedness introduced a new note in sculpture, one which was to become increasingly influential as the sixties unfolded. If the colour contributed substantially to the 'characterization process', other factors also help elucidate the identity of the sculpture. King was now moving away from the idea of sculpture as an inert object, or 'thing', to a notion of sculpture as possessing a particular identity. For King, the existence of an identity in the work meant that the spectator must enter into an active engagement with the piece:

> Sculpture is a translation or mimicry of the position of man in the world. (5)

The human size of the sculpture, and its emphatic verticality, create an awareness of physical parity and therefore reciprocation between the spectator and the sculpture. Frontality is also an important ingredient in forming an identity:

> One is not dealing with an abstract thing but something is taking shape as the result of an activity ... YOU-ME idea between object and creator is a line and must have frontality. Recognition of you and me relationship keeps the distance and gives rise to a back, to a right side, to a left side. (5)

Rosebud 'presents a face', its identity enhanced by the subtle differentiation of front from back.

As a method of structuring, the cone grew from leaning two things together at the apex. Its use involved King in traditional sculptural issues, such as the relationship between mass and volume to which he brought a new approach. In *Rosebud* volume is present without mass; forms encompass and inhabit space yet are not weighty or dense. The fact that the cone is hollow is confirmed by the narrow lip of the lining visible at the base and by the edge of the mantle. This edge has been deliberately thickened to a depth of half an inch so that it is not read as a linear pattern on the surface but as the perimeter of a plane under which a second, separate green surface lies. King found this particular shade of pink a distinctively unsculptural colour; it was not only devoid of historical associations but it was the colour of walls. As such, he felt it affirmed the surface nature of the outer shell.

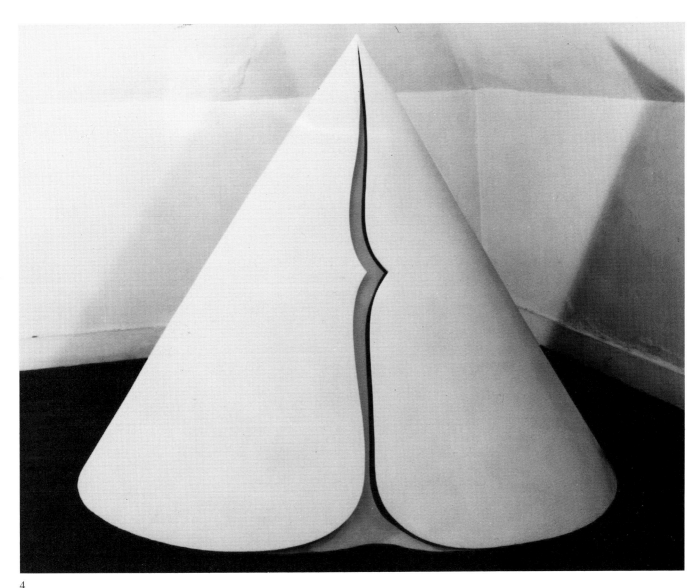

4

5

Twilight 1962 (second version)
plastic, aluminium and wood 102 × 132 × 168
light blue (blades), salmon pink (knob), dark blue-grey
(triangle), red–orange–green on perspex
Bryan Robertson

Practical considerations led King to work with fibreglass. A novel material in sculpture, it opened up new possibilities since it allowed the artist to mould freely invented shapes and open, light-weight structures not possible with plaster or other traditional materials. Yet like wood, concrete and plaster which King had used previously, fibreglass permitted an organic mode of composing, a mode which he used to evoke analogies of growth, mutation and metamorphosis. As such, this is the antithesis of welding with its 'impossible conjunctions' of elements which at this time he strongly eschewed as unnatural. Yet King did not make a fetish of 'truth to materials'. In answer to the question whether he was interested in 'material as a thing in itself' King replied:

> I would say *matter* rather than material. By that I mean I am much more concerned with the general properties of materials than with individual differences. I tend to impose the properties of materials on my shape, changing them at will, rather than uncovering them in their particular form. (2)

Since the resin had no real colour of its own, colour could either be added to the liquid material or applied to the hardened surface. King preferred the latter method partly because those aspects of the work to which colour contributed most directly – character, emotional tenor, and expressive surface – tended to reveal themselves only gradually, during the making of the piece. Decisions regarding colour were thus more appropriately explored late in the process of making the work. King had initially given *Rosebud* a brushy pink coating but subsequently felt that an even matt finish better emphasised the surface quality of the outer mantle, and he repainted it. In *Twilight* he extended his delight in the possibilities of multi-coloured sculpture: opaque and dense colour contrasts with transparent surfaces, and gloss and sheen with a matt finish, to create a form quite unlike anything seen before in sculpture. This vital colour helps transform the work into a marvellous object.

Twilight belongs unmistakably to a man-made environment. In contrast to the landscape connotations infusing much of the abstract painting in England in the fifties King and his contemporaries wanted an art produced out of the urban culture in which they lived. It was essential to King, as to his fellow sculptors primarily working with steel and coloured forms at St Martin's, that his sculpture should look man-made and not formed by the forces of nature, as did that of Moore and Hepworth. It should readily take its place in a human context; its proper site was an interior one. The art of creating sculpture was viewed as a purified form of object-making. From images like ladders and windows, which were obviously man-made, King had evolved a kind of imagery which was abstract, devoid of functional purpose yet indubitably man-made. Since its animate character separated it from the inert world of furniture, the spectator's experience of it was active, involving an examination of this intruder:

> Sculpture is the one kind of art that really flaunts itself . . . it is there for no purpose . . . it's just there, taking up space, your good space, it is an offence – I can understand that. (7)

Through such engagement King believed the spectator might learn more about himself, the raison d'être for sculpture, as epitomised in this statement from 1977:

> Sculpture is for me a way of intensifying 'looking' . . . thereby offering to the spectator a new and fuller sense of what it is like to see and perhaps to be. (11)

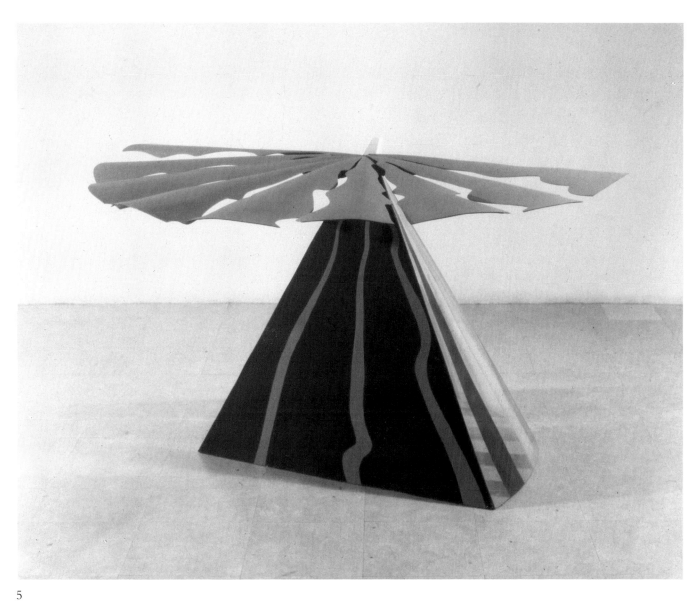

5

6

Tra-la-la 1963
plastic 274 × 76 × 76
The Trustees of the Tate Gallery

The cone shape stimulated a great variety of ideas as may be seen from a comparison of *Genghis Khan* with *Tra-la-la*. In the former the artist has concentrated on creating a new being, a character whose distinctive sculptural lineage has been infused with a novel aura. In *Tra-la-la* King said he wanted to explore the notion of a sculpture which started somewhere other than on the ground. Instead of building the form gradually upwards from a low centre of gravity and tapering it off towards the top, he seemingly starts the sculpture in the air and 'lands' it, bring it down to base. This is achieved in part by an emphasis on colour and shape rather than on the mass of the forms; the slim cone stretches upwards to meet the taut shape of the baluster whilst the uppermost form, materialising in mid-air, gathers energy as it whips itself through a tense spiral before descending in a svelte gesture to anchor the baluster in position.

This almost wayward imagery is startling, yet King's attitude to the art of the past is never iconoclastic. He does not want to effect a drastic break with tradition but, on the contrary, to examine it in a new light, an attitude he first stated in 1961:

Traditional but modern. ... Today's concerns are a clearer and purer expression of old ideas. (5)

Tra-la-la recalls Henri Laurens' *La Sirène,* a sculpture which King knew well through reproduction in Carola Giedion Welcker's *Contemporary Sculpture,* then one of his treasured possessions. The similarity is, however, a product of a shared concern with certain fundamental issues rather than a case of direct borrowing: a traditional problem has been accorded new solutions. It is this rethinking of basic tenets of monolithic sculpture which links King's seemingly disparate works at this time.

7

Genghis Khan 1963
plastic and fibreglass 213 × 274 × 366
The Trustees of the Tate Gallery

Edition of three:
Peter Stuyvesant Foundation
Tate Gallery, London
State University of New York at Purchase

The playful spirit and witty form of *Rosebud* presaged new directions over the next few years. Running through King's oeuvre as a leitmotif is a baroque strain of imagination which delights in a rich interplay between form, image and allusion: this reaches a peak in *Genghis Khan,* an assertive personage who sallies forth to greet the unsuspecting spectator. King again uses a mantle as a thin surface layer which conceals an inner form of differing substance: the glutinous matter seeping beneath the outer garment gives *Genghis Khan* an unexpected buoyancy for the ruffled edges seem merely to skim the ground. King has outlined further ways by which this effect of lightness was achieved:

Outside contour can work with or against inside shape, making it more or less tangible ... these tangible factors may disappear or be reduced in relation to other factors. For instance, the all round contour of *Genghis Khan* has more formal entity than the ground contour and it also echoes it and dominates it, thereby helping to make the sculpture float off the ground. (2)

The antlers serve also to increase the scale so that *Genghis Khan* dominates the observer, adding a slightly regal aura to this enigmatic figure. The self-sufficiency of the sculpture, its existence as an independent being with a character of its own, was of paramount importance to King. Undeniably three-dimensional, these cones demand a head-on confrontation; standing boldly in our space they insist upon engagement and appraisal.

King regards *Genghis Khan* as the last of his works to have a deliberate and specific representational reference. When questioned in 1965 about the allusive content in his work King replied:

I would say that formal themes run through my mind for long periods at a time. In their general characteristics they relate to formal problems, but in the working out of an individual piece, association to natural forms, phenomenal events or contemporary imagery do crop up [yet] they remain of secondary importance and their main value lies in the fact that they help to formalise an idea which seems to exist in the mind mostly in terms of feelings and shapes based around a formal event. For instance, when I made *Genghis Khan* I did not think of mountains and clouds, but the idea was based around a bursting event using flowing forms, bounded in by side walls and the ground. (2)

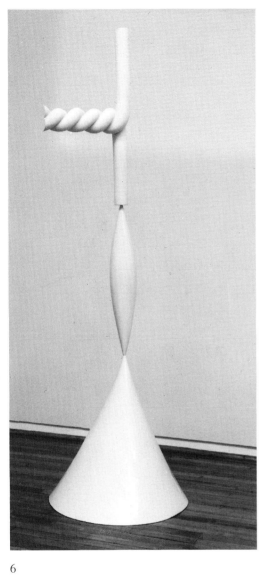

6

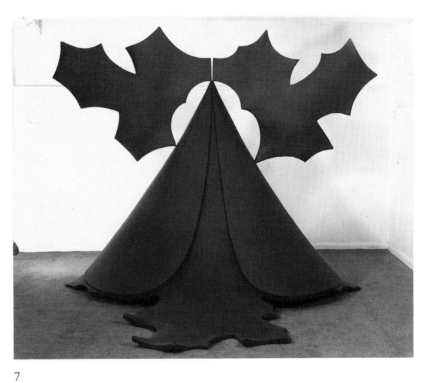

7

8

And the Birds began to sing 1965
sheet metal 168 × 213 × 213
The Trustees of the Tate Gallery

Edition of two:
Tate Gallery, London
Los Angeles Museum of Art

Despite the fact that this sculpture is one of the most bold of those using the leitmotif of the cone, it once again deals with issues long familiar in monolithic sculpture. *Twilight, Genghis Khan* and *Tra-la-la* had all explored ways in which a solid object might inhabit and dominate space. Not only do they displace space through their bulky volumes, shorn of the ponderousness normally associated with solid form, but they actively engage with the surrounding milieu. In *And the Birds began to sing* King was concerned to see whether he could contain a volume of space within the cone: he wanted to use space positively, shaping and defining it. Both Hepworth and Moore provided precedents for creating a spatial cavity by excavating a lump of matter, but King approached the problem from a different angle. Rather than contrasting the contained hollow with the surrounding material he sought to reduce as far as possible the bulk of the outer form in order to emphasise and enliven the interior.

The inert matt exterior contrasts sharply wih the glossy orange core. Set at an oblique angle the smaller cones seem suspended freely in space and rock in an oscillating rhythm, for the sheen of the orange reflecting on itself blurs the structural relationships, dissolving the solid walls in a glow of orange light. The whimsical title comes from an association with the nursery rhyme; it is metaphoric rather than descriptive as are most of King's titles at this time. Bestowed on completion of the sculpture, their main function is to encourage poetic allusion:

> I was trying not to get a literal quality, so that from the title you could conjure up the anticipated image, but to match it in a different way with appropriate rhythms that somehow echoed the rhythms of the work or were suggested by it. (9)

Although made when King was teaching at Bennington College in Vermont, *And the Birds* bears no obvious traces of his new context but appears to carry forward certain preoccupations stretching back to *Rosebud*. This was the first sculpture he could afford to have professionally fabricated in metal. The precise finish available in sheet-metal, but not easily attained in resin, enhances the crispness and pungency of the image.

9

Barbarian Fruit 1964
cast aluminium and wood 152 × 152 × 91
Rowan Gallery, London

After the works of 1962–63 King felt that he was getting too far from the question of mass: *Barbarian Fruit* was the result. He described it as 'an oddball . . . it goes back to old ideas'. (4) Reminiscent of Brancusi in structure and form, in scale and composition *Barbarian Fruit* seems to belong to the world of still-life objects rather than to that of animate beings, as did the cones. Eschewing both the singing colour and lightness of form of the fibreglass and resin sculptures, its softly slumping upper forms (paradoxically cast from aluminium) contrasting with the stolid star-like layers below, *Barbarian Fruit* resembles an exotic offering on a ceremonial pedestal. The overall symmetry and the squat stable proportions of the pedestal enhance this presentational mood.

Having finally elaborated a set of principles, King seems to have found threatening the very possibility of their becoming canonical. Volume but not mass, applied colour rather than natural hues, a whimsical mood, standing directly on the ground, and an animate character were characteristics common to much of the work of the preceding two years: all are contradicted here as if to demonstrate that current tenets may always be discarded. King's habit of questioning his precepts originates from his student days at St Martin's School of Art and owes much to Paolozzi and Caro. In his teaching the former stressed the importance of individuality, of an indifference to local trends in favour of international traditions, and the necessity of backing one's own intuitions however unconventional. The latter, following his visit to the United States in 1959, encouraged a rigorously critical attitude to orthodox premises in sculpture. From their joint example, rather than their work, King developed both a willingness to test constantly every aspect of his ideology, and a confidence in exploring his catholic sensibility. The sudden reversal of precepts in *Barbarian Fruit* stems from this approach.

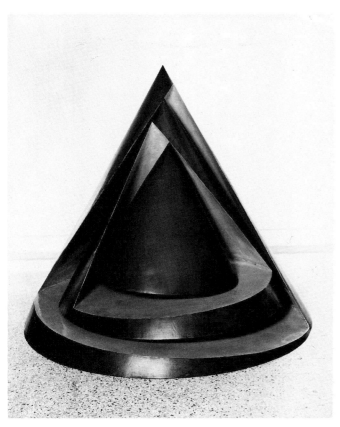

8

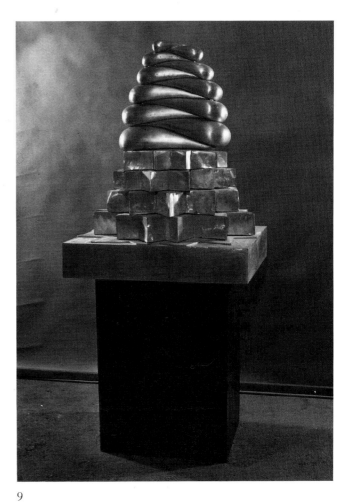

9

10

Through 1965
fibreglass 213 × 335 × 274
dark green (boxes), medium green (cone),
medium red (boxes)
Collection Ulster Museum, Belfast

Edition of three:
Alistair McAlpine Collection, London
Galleria dell'Ariete, Milan
Ulster Museum, Belfast

Through, the last and largest of the cones, is also perhaps the grandest. It synthesises aspects of many of its forebears but gains a new hieratic dignity through the addition of a kind of podium. By means of colour this plinth is clearly related to the main form above yet it is sufficiently differentiated to add a note of ceremony to the whole. With its inert arid green skin shielding a lustrous interior *Through* also suggests an exotic fruit. King here rings yet further changes on the relationship between mass and volume, solid and space, for the great bulk of the cone has been sliced to reveal its succulent kernel, as the narrow interstices between the wedges flood with red light which promises to spill beyond the taut triangular silhouette. On a visit to New York after finishing *Through* King saw a wooden Buddha which impressed him deeply:

> The wooden Buddha greatly influenced me, it was important because it was a way of making a different kind of sculpture, a non-Western way ... absolutely still yet with great vitality. This confirmed *Through* where there was expansion through stillness. (9)

As in *And the Birds began to sing* there is a sharp distinction between lateral and frontal viewpoints. From the side *Through* appears more compact, not yet penetrated and exposed, inviting the viewer to explore further and discover the symmetrical front. The large scale allows *Through* to stand commandingly before the spectator like some monumental atavistic idol, potent and mysterious.

In the late fifties King had been much impressed by Abstract Expressionism, and the work of the first generation of painters in particular, whereas he felt an absence of spirituality in the abstract art of the sixties. From Rothko especially, he saw a way in which scale, frontality and colour could be deployed as a means of engaging the viewer physically and emotionally with the work in front of him. A similar approach to engagement is found in *Through*. For King, this confrontation between viewer and sculpture has metaphysical overtones; he believes that a man may come to a fuller self-realisation through a physical engagement with his context. If this notion of sculpture as an intruder in man's space who must be confronted has existentialist overtones, this is not surprising for King has long been interested in the writings of Sartre and Camus, and in their belief that the means to authentic self-knowledge lies in an active engagement with the phenomenal world. Through his friendship with William Tucker, King had also come into contact with Merleau-Ponty's theories of perception as a physically based activity: 'To perceive is to render oneself present to something through the body.' The manner in which this emphatic engagement between viewer and sculpture may effect greater self-awareness has been well-expressed by Tucker (BBC Transcript 1965):

> You can have a private relationship with a sculpture, it is not dominating you from on high ... it is as though it is another you outside yourself. And the things that happen to it are possibly the things that inside yourself with your eyes shut you can imagine happening to *you*, it's not your sort of experience inside yourself.

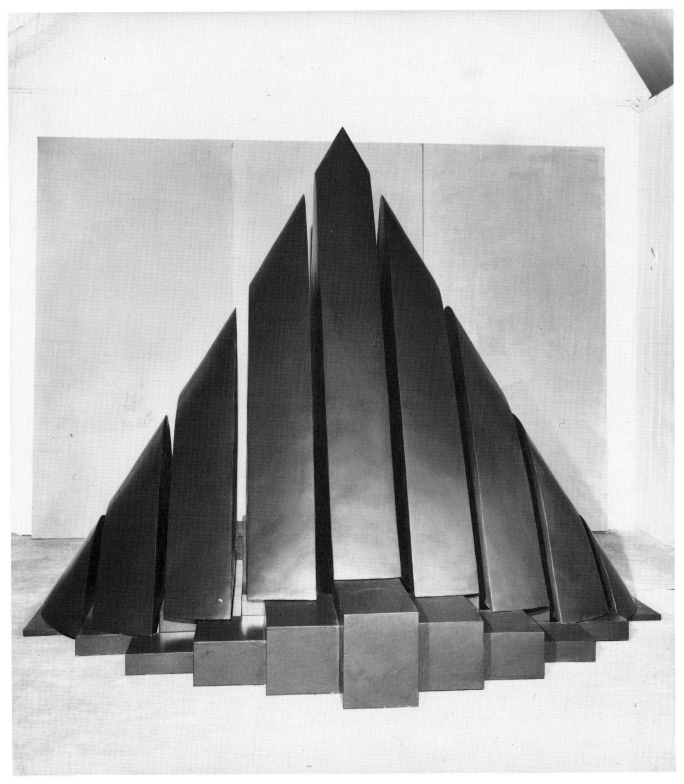

10

11
Point X 1965
plastic 183 × 188 × 152
Rowan Gallery, London

Edition of three:
Galleria dell'Ariete, Milan
Arts Council of Great Britain
Rowan Gallery, London

12
Slit 1966
arborite 198 × 325 × 175
red, semi-gloss; white, semi-gloss
Musée National D'Art Moderne – Centre Georges Pompidou

Edition of three:
Feigen Gallery, New York
Galleria dell'Ariete, Milan
Musée National D'Art Moderne, Paris

Compared with the work of the previous four years, *Point X* marks a considerable redirection in King's concerns. After 1965, perhaps surfeited by his investigations into monolithic form, he began to engage warily with some of the issues raised by a constructed open-form sculpture. *Point X* reflects this shift, at the same time as it deliberately recalls *Declaration*, as if King were returning to his roots or basic precepts. In 1968 he said of *Point X*:

> there's a jump away from the concept of the cone ... and towards new shapes which didn't have the kind of object definition that the cone has and which would allow me to open up more, to get more to grips with space. *Point X* is the beginning of this; it related back to *Declaration* in the sense that it uses very primary shapes like squares, circles, triangles, and in repeating rhythms. But suddenly the two pieces are separated – there's no longer a running axis through the centre. The axis is the lime colour moving around it. (5)

These elemental forms are now composed in a manner far removed from the 'natural balance' of the earlier work for King propels them upwards through space, anchoring them in position by a concealed bolted spine so they seem self-supporting. Structure is no longer explicit. As in *Declaration* geometric regularity is tempered to enhance the legibility of the image; the outer edges of the triangles and squares have been bevelled so that from the front, the sole viewing point, the linear movement is emphasized and clarified. A symmetrical arrangement and frontal format dictate the major vantage point as so often in King's sculpture to this date.

Unlike *Declaration* in which the arrangement of planar forms gives an overall volumetric or cubic configuration, in *Point X* line is the focus of interest. The glossy lime strips, foils to the dull brown planes in which they are set, cause the sculpture to be read in terms of the peregrination through space and around solid form of a snapping acid line. Its path lies clearly in three dimensions, it is not confined to a single plane as it might be in a conventionally cubist work. The 1965 retrospective of Morris Louis's paintings at the Whitechapel Art Gallery deeply excited King who rarely felt as strongly about American sculpture. In the swift movement of this tangible line through space echoes of Louis may be discerned.

The title, suggesting the movement of an 'x' point through space is both more restrained and more neutral than had been King's habit. In accordance with the changing nature of his concerns, allusions are discouraged as much by the name as by the use of primary forms. *Point X* is a kind of theoretical stock-taking.

The years 1965–6 were important for King's career in a number of respects. 1965 saw the debut of the circle of sculptors at St Martin's in an exhibition entitled *The New Generation* held at the Whitechapel Gallery. Although falsely dubbed a movement by the press, their work shared only general concerns, including the use of bright colours and new materials, (notably fibreglass and resin), an abstract language of form and a mood of lyrical playfulness. These broad affinities should not veil the substantial differences amongst them, not least King's allegiance to a sculptural heritage rather than to pictorial conventions. While several of them effectively launched their careers at this moment, for King by contrast the exhibition marked the culmination of a phase. Judged the dominant figure by critics he was already relinquishing many of those concerns which linked him to this group.

In 1966 he had his first one-man exhibition in New York at the Richard Feigen Gallery, the same year as he participated in *Primary Structures* at the Jewish Museum in which minimal sculpture was first seen *en masse* and to considerable public acclaim. Critical commentary now tended to polarise developments in progressive sculpture between the austerity of the Minimalists and the exuberant, colourful British School. However simplistic such a reading was, a new spirit of restraint and a sparseness in form soon became prevalent and tempered even King's imaginative flights. In *Slit* something of the formal rigour and use of repetition favoured by the Americans has been fused with vigorous colour which is British in flavour. Yet the emotional charge of *Slit* is higher than that of minimal sculpture and its physical presence is more emphatic than that of much English work.

King defined his aims at this time as a desire 'to get more to grips with space and to utilise the ground in a more active role'. (5) In doing so he relinquished his former use of overtly three-dimensional components and a static frontal image. He began to expand his work along the ground in an effort to use it more actively and not merely as a surrogate pedestal. Four flat overlapping elements dart boldly across our path of vision and establish an intimate physical engagement not unlike that of certain field paintings (e.g. Kenneth Noland's horizontal stripe paintings of 1964–66), perhaps the nearest King ever came to a pictorial emphasis.

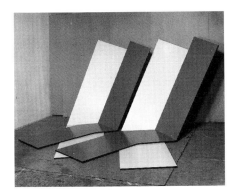

12

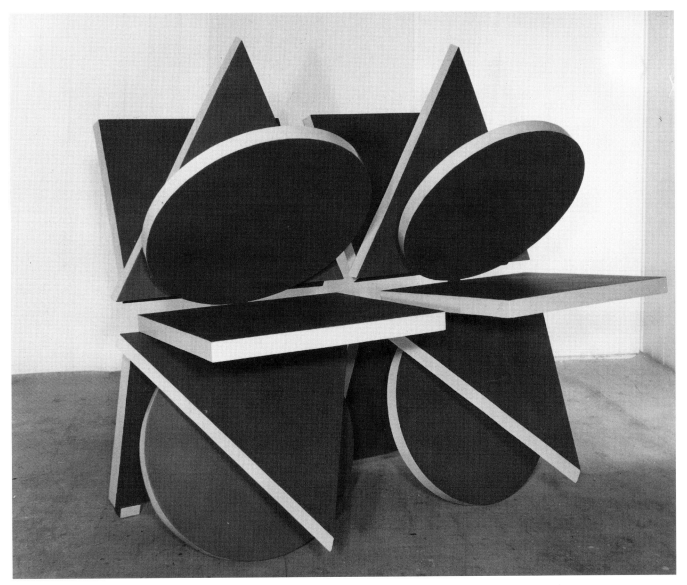

11

13

Slant 1970
arborite 213.5 × 547.5 × 190.5
cream, semi-gloss
Rowan Gallery, London

Edition of three:
Feigen Gallery, New York (2)
Rowan Gallery, London

Slant carries further ideas first mooted in *Slit* but it now expands beyond the confines of a single viewpoint or glance. By the addition of two more elements King has avoided the impression of a single dominant form, or holistic image, in favour of a repetition of parts, of indentical units, moving through space. In lieu of the former stationary confrontation *Slant* extends laterally within a frontally aligned format. This dynamic effect is enhanced by the slight overlapping of forms; the resulting play of shadows seems to register the velocity of one unit succeeding the next.

> I have been concentrating on making a sculpture in which the furthest thing away from the middle is not an appendage but an extended happening of what exists in the middle, hence making the middle part of a total event, equally important to all other events. (8)

Slant was originally coloured green but when King decided to exhibit it outdoors, in a park, he repainted it red so that it would contrast with its setting. In this context *Slant* affirmed its man-made quality, in contrast to the biomorphic or organic appearance of sculpture of the fifties.

14

Brake 1966
fibreglass 213 × 366 × 488
grey-bronze, semi-gloss
The British Council

Edition of three:
Kröller-Müller National Museum, Otterlo
Galleria dell'Ariete, Milan
The British Council

To date King had sought to engage the spectator primarily by forcing him to confront the sculpture as an intruder in his space. Typically, the viewer stood stationary in front of this alien object, roughly comparable in scale with himself, and decoded its characteristics. In *Slit* a change occurred in that planar forms were substituted for overtly three-dimensional elements and the sculpture now moved across the viewer's field of vision. Yet *Slit* continues to occupy a substantial space, for the horizontal bases stretch well forward towards the spectator and the upper halves tilt backwards at an angle: it covers considerable territory without acquiring the traditional attributes of mass and volume.

Brake extends these preoccupations, but for the first time in King's oeuvre it demands a number of viewpoints in order for its character to be fully revealed. The spectator is kept alert by the manner in which this chameleon creature approaches or taunts him from different angles. At one place he is infected by what King calls 'foot-awareness' as he becomes anxiously conscious of a horizontal slab cantilevered precariously just above toe-height: from another position a form thrusts out at eye-level, its sharp angles protruding menacingly. Elsewhere, the whole seems to gather itself into a compact form: retreating from participation, it employs a detached element to act as a kind of barrier to ward off the spectator's approach. The sombre hue, austere format and ominous mood contrast sharply with its predecessor's bright vivacity. Where formerly the interplay of colours helped activate the surrounding milieu, now the pitching at divergent angles of ponderous components fulfils this function. Despite the diversity of viewpoints, a sense of 'wholeness' develops owing to the close family resemblance amongst the parts. They are of the same order and clearly belong together, like a skeletal core, even when not physically joined.

> There is a spiralling movement in *Brake* reminiscent of the tradition of form in the round – (Bernini, etc.). The spiral in its movement describes a cone – I was in a way retracing for myself and within my own work the earlier historical path of sculpture from volume to internal reduced structural forms . . . part of the attraction of the piece for me was the constant section of the form. It meant I could use the same mould for different parts. (9)

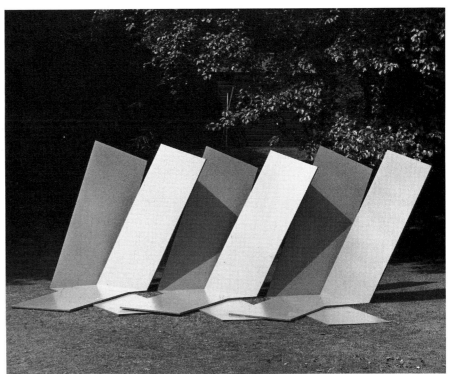

13

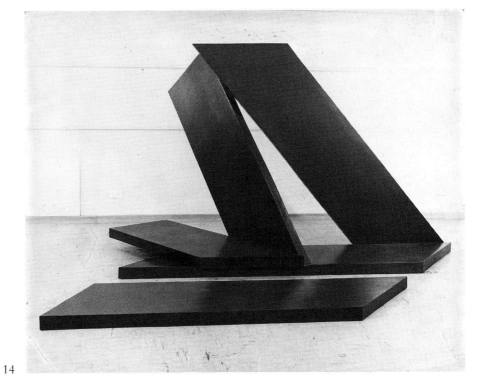

14

15
Call 1967
fibreglass and steel 442 × 457 × 549
Rowan Gallery, London

Edition of two:
Tate Gallery, London
Rowan Gallery, London

In *Call* King carried further his interest in multi-partite sculpture in an attempt to give greater priority to space itself. Since he did not want to create an installation or environmental work the individual components were not conceived for their image quality per se but as agents which interact to define, shape and mould space. The emphasis is now on light and space rather than mass. As King said in 1968:

> Colour frees light from a fixed angle from the outside and makes it internal and pervading – it becomes one with space ... A lot of sculpture recently has been ground conscious and therefore base-controlled – colour-light creates the context of the vertical with the ground acting as the horizontal.
>
> I would also like to use colour with more presence, as though it were a thing in itself pervading the whole work, so that one is left with a feeling about colour as much as anything else.
>
> I am striving to work in materials and shapes that have no memory or history where an experience is created by positioning not shaping. (5)

Like *Brake, Call* exploits activity at different heights of the body, and beyond the confines of a single glance, in order to render space plastic in what King defined in 1967 as 'un modelage de l'espace où les formes limitent sans délimiter' (King occasionally formulates a statement in French for it permits him greater precision and conciseness of statement).

King felt that the quantity, weight and density of orange employed on these forms would be picked up and transformed like the modulation of a key motif in music, backwards and forwards across the space in rhythmic interplay: the activity of colour in this ambiance gives the sculpture its identity. King kept close watch over colour relationships, choosing orange and its complementary green in an effort to divert attention from the solid components to their interaction through space. The columns were designed to provide the main effect of lighting:

> ... if you take the verticals away the intensity of the colour goes down ... they are lifting the colour. (4)

The title refers to the way the components interact, calling to each other across space by means of their colours, effulgent and sensuously active. King spoke of

> wanting colour to be so intense as to be a kind of physical thing rather than an optical one ... my sculpture is still essentially a physical experience. (4)

16
Span 1967
steel 244 × 472 × 533
dark blue, high-gloss
Kröller-Müller National Museum, Otterlo

Edition of two:
National Gallery of Victoria, Felton Bequest, Melbourne
Kröller-Müller National Museum, Otterlo

King is not a prolific sculptor; he customarily explores a problem within a single work rather than seeking its solution through multiple variations. Nevertheless works can often be gathered into groups defined by a shared problem or by the continued engagement with a particular form, like the cone. *Span* explores new aspects of issues first touched upon in *Call* and *Blue Blaze*, yet it concentrates less on the qualities of a particular space than on the question of the interaction between forms and their context. Employing more elements than *Call*, *Span* insists on a family likeness amongst its components.

These elegant forms, reaching just over head-height, have a solemn aura reminiscent of ancient megaliths mapping out sacred territory. *Span* began as an assembly of five graded columns which then became two columns and three tilted slabs. A box-like shape subsequently replaced one of these and a companion box was also added in order to divert attention from too-centralised an arrangement and to anchor the movement of the viewer to the threshold of the sculpture:

> *Span* began with the idea of column shapes ... others came about by experimenting in the studio ... changing shape and proportions to make the space 'read' the way I wanted it to. (4)

The minute foot-piece not only alerts the spectator to the dimensions of the work but its quirky form adds to the particularity of the location, contributing to its identity. As in most of King's multipartite works, in *Span* a very fine adjustment in the siting of parts controls the spatial experience.

> In *Span* the distance between the parts is precise to an inch unlike *Blue Blaze* where the axes are precise but the parts can expand or contract away from each other according to the requirements of the available space. *Blue Blaze* is the only work I have done which had this particular character of no fixed distances between parts. (9)

Central to *Span*'s character is the lustrous deep blue surface which absorbs, repels and distorts the flow of light between the components. Shapes seem to dilate, spinning reflections across the narrow intervals with unexpected dynamism. The *Cubis* of David Smith, some of which were shown at a retrospective of his work held at the Tate Gallery in 1966, perhaps provides a prototype for this use of a reflective surface which partially dissolves mass as it activates space through the motion of light playing from form to form.

On most occasions King prefers to mix his colours rather than use ready-made commercial hues in order to enhance the individuality of

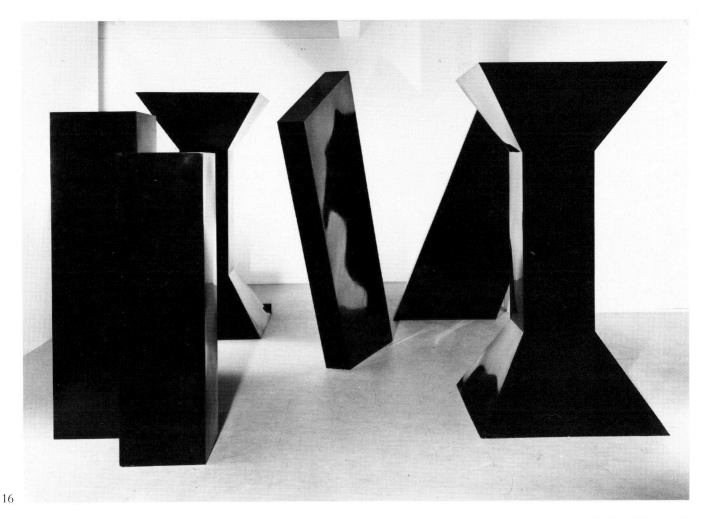

16

the sculpture. He also carefully discriminates between the effects of brush, roller and spray-gun, the different procedures becoming integral to the total effect. The use of a spray on *Span* serves to merge the surface colour with the solid form, so that colour no longer feels like an applied skin. Light seems to break into the forms rather than simply playing over the surfaces.

With these multipartite sculptures King generally made a mock-up in hardboard and wood and then had the final version professionally fabricated in steel or aluminium. He tried to counter the anonymity of this indirect manner of working by introducing intimate or personal details and by carefully controlling the scale in parity with the observer. Metal was essential in that it permitted the exactitude of finish necessary to the final effect.

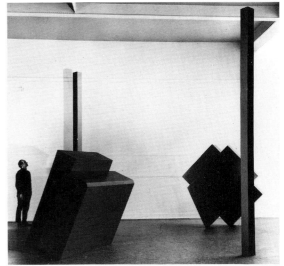

15

17
Blue Blaze 1969
aluminium $183 \times 762 \times 610$
bright blue, extra matt
Collection of Mrs. John D. Murchison, USA

Together with several of his colleagues at St Martin's including Caro and Tucker, King has had a university education: he read modern languages at Cambridge between 1954 and 1957. This background meant that they had a less extensive practical training in sculpture than was customary, and perhaps also accounts in part for the conceptual or theoretical bias underlying their approach to sculpture. King usually conceives of his work in terms of general issues which are then explored in specific instances; sometimes a problem may admit of prolonged scrutiny over several works, each exploring different strands of a particular issue.

In many works prior to 1965 King sought to elicit the spectator's participation with sculpture in the form of a single object, but for several years thereafter the use of multipartite sculpture altered the terms if not the intrinisic nature of this involvement. He now accorded greater emphasis to both the affective role of colour and to a variety of viewpoints in shaping and defining the spatial context. Within this group of multipartite works, *Blue Blaze* is unusual in requiring a very specific context: there must be at least two right-angled walls present. Changes in scale, direction and shape of the components keep the observer alert, and enhance the particularity of the location. As King wrote in 1968:

> The physical aspect of being involved with the work has always been very fundamental to me. I think this is what has made me use scale the way I have. The idea of space that interests me is always a physical space, it isn't an abstract or ideal notion of space but a felt notion. (5).

In *Blue Blaze* it is colour above all that focuses the identity of this spatial experience:

> I called it *Blue Blaze* because of the feeling of colour running through something and disintegrating it, disintegrating shape, isolating it ... The colour is reflected off surfaces in sculpture. You feel colour is actually colouring light and colouring space in front of itself. I think colour in sculpture actually works outside itself, it seems to affect the space around the sculpture, I feel: this has something to do with the way I look at Matisse's work. (5).

Colour now operates in a way substantially different from that seen for example in *Point X* or *Slit* where the tangibility of moving coloured form was paramount and not the sense of dematerialised colour invading the surrounding context found here. Something of this antithesis in approach to the role of colour may be discerned in the distinction King draws between the ways in which recent American painters and Matisse have used colour:

> I feel that Matisse's use of colour, compared to a lot of recent work, is much more optical and to do with an expression of light as understood by the Impressionists possibly ... I feel that most American painters have used colour in a very physical sense ... My first impression on going to the Louis exhibition at Kasmin's was being faced with physical objects that I could grasp almost – bands of colour, kind of hanging in space, one next to another ... [with] Matisse's use of colour ... the surface is completely irrelevant ... [colour is] always outside the surface, always in front somewhere. (5).

Charles Harrison has given a potent description of the way this conception of colour operates in *Blue Blaze*:

> In *Blue Blaze* colour is used to better effect than in any other of King's sculptures. The combination of intensity of colours and mattness of surface ... draws attention to the disposition of forms, and thus to the whole 'shape' of the complete work – the picture it paints in space – rather than to the nature of the particular and individual shapes which compose the sculpture. The most dramatic contrast is not between solid and void but between blue and not-blue. The colour comes over the gap between one piece and the next. ... The colour unites them in their actual grouping ... They are certainly not united by what they hold in common, as forms. (3).

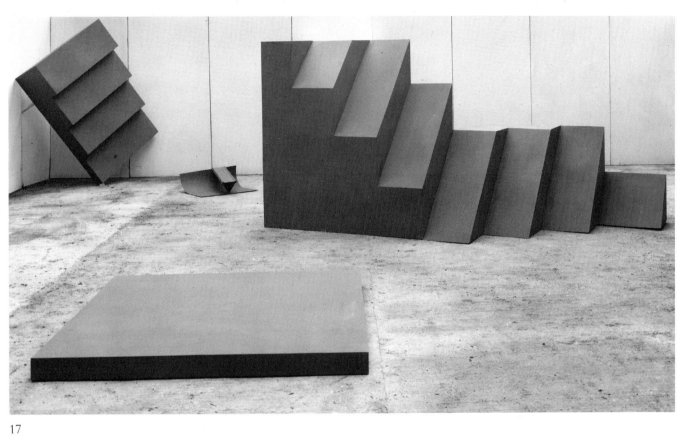

17

18
Reel 1 1969
steel, aluminium and plastic 165 × 380 × 425
red, gloss; light green, matt
Royal Museums of Fine Arts of Belgium, Brussels

Edition of two:
Kröller-Müller National Museum, Otterlo
Royal Museums of Fine Arts of Belgium, Brussels

The period 1968–9 was transitional in King's career in several respects. With Bridget Riley, he was the British representative at the Venice Biennale in 1968. The combination of an extensive showing of his work, and an international context, allowed him to view his sculpture in a more detached manner. For a one-man show proposed for the Whitechapel Gallery later the same year King flirted with the idea of making an installation piece but finally rejected this notion on the grounds that it would involve him in a number of issues (e.g., of specific sites and temporary duration) which he felt were irreconcilable with his general approach to sculpture. Rather than jettisoning these deeply held precepts King preferred to test them further and therefore returned to the principle of sculpture as a single object, a physical entity. *Reel 1* marks this reorientation not of principles but of direction. It did not, however, entail a return to the monolith, for King wished to incorporate his experience of moulding and structuring space, as realised in his multi-partite sculptures, within his notion of sculpture as a single object. Bounding an internal space in a sequence of lifting, bending and stretching movements of varied tempo, *Reel 1* was the solution. Although markedly different in form from his preceding work it brings yet another variation to King's longstanding conviction that sculpture should be nothing other than a certain kind of object, parallel yet separate from nature:

> La sculpture n'est pas un objet littéral. Mettant en jeu le phénomène de l'*identification*, elle peut fort bien se présenter comme un autre vous-même. (6)

A large retrospective of Matisse's painting at the Hayward Gallery in 1968 deeply impressed King as did the 1970 Grand Palais exhibition. It was the late papiers découpés which particularly fascinated him, and seem to have left their mark on his work at this time. In *Reel 1* the particular combination of red and green in vital opposition immediately recalls the French artist, and similarly the choreographed sequence of twirling shapes meeting with elegant poise at various levels of the body. With a more intimate and a more anthropomorphic scale than works like *Call*, *Reel's* unfolding rhythms incite a kinesthetic response in the viewer who circumnavigates the sculpture. In welding and bolting the joints together King avoids those 'impossible conjunctions' of forms he had previously condemned in constructed sculpture. A natural balance and a direct response to gravity characterise these meeting points and interactions of form as truly as in his sculpture of the early sixties. The gesturing shapes, new lightness of form and expansive movement bring an unprecedented lyricism to King's work, recalling the élan and joie de vivre of Matisse's Blue Nudes of the 1950s.

19
Crest 1970
aluminium 56 × 129 × 112
silver blue, gloss
Bradford Art Galleries and Museums

Edition of four:
Private collection, London
McCrory Corporation, New York
Bradford Art Galleries and Museums
M. A. Strauss, USA

In 1969 King moved to a large studio in the country which he still uses, about forty minutes drive from his London home where he maintains a second smaller studio armed with different tools. Large works in steel were made possible by the spacious confines near Dunstable while smaller works continued to be made in London. This segregation of activity contributed to a substantial shift in his treatment of scale.

In accordance with its intimate scale *Crest* gives the impression of an intricate profusion of forms necessitating a close scrutiny. Proportions and shapes seem to have been determined by the dimensions, grip, pressure and manoeuvrability of hand and fingers, cutting, bending, folding. Tools do not interfere to distance the making, their presence feels invisible, mere extensions of the activities of the hand. King disliked having others fabricate his sculptures since he felt that he lost personal contact with the material and that there was inevitably too much emphasis placed on the preconceived idea which was then simply carried out automatically: He criticised minimal sculpture for its lack of this sensitivity and warmth given by direct handling. In *Crest* he exploits the lightness and pliability of aluminium, shaping and bending it intuitively into a form which seems to skim the ground rather than bear down heavily on it:

> I cannot go into nature and find an idea. Work comes out of the mind, through handling materials, not through resymbolising nature. The philosophy is not a worded kind, it is intuitive. (5)

The multi-axial inflection of forms overlapping in space makes *Crest* more three-dimensional than many cubist works to which it is tangentially related. When adopting a cubist–derived language of planar forms King reverted, characteristically, to early twentieth century precedents as the appropriate heritage and starting point for his investigations. *Crest* has certain affinities with Tatlin's abstract reliefs which King regarded as half-way between modelling and assemblage, a statement which might apply equally to *Crest*. The impression it gives of having been made from a single continuous sheet of material produces a sense of organic unity notwithstanding the complex manipulation of forms and the assemblage technique.

Caro's table pieces also provide a point of comparison since they initiated a general interest in small scale sculpture, yet the difference in approach between the two artists is considerable. King emphasised manual manipulation of the stuff rather than the interaction of neutral

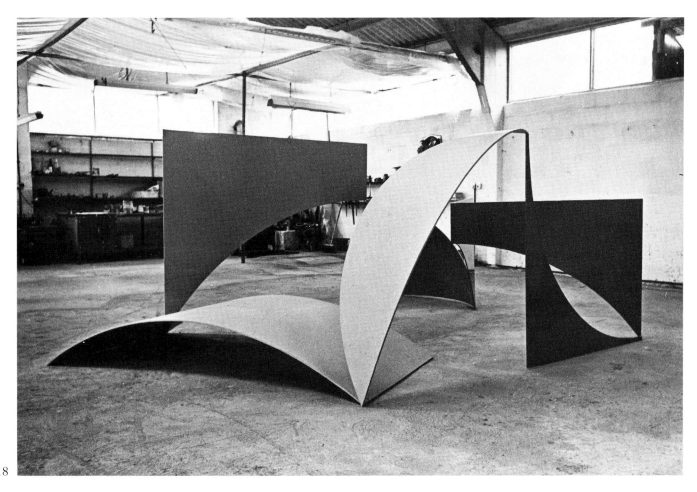

18

found forms as in Caro's work: for King, making is essentially a physical activity:

> If it were possible to register and codify in some commensurable form the sensation of our bodies but especially of our hands sculpture would not exist – what makes sculpture possible is this impossibility and the attempt to find visual equivalents. I guess this applies equally to dancing. To close the gap between the eye and the hand so that the hand sees and the eye feels. (13)

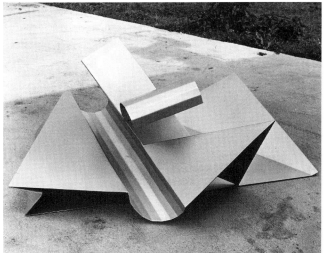

19

20

Quaver 1970 (artist's copy)
aluminium 117 × 73.6 × 43.2
blue-purple, gloss;
yellow, gloss; red-orange, gloss
Collection of the artist

Edition of two:
Private Collection, London
Alistair McAlpine Collection, London

Pliable and lightweight, aluminium became an obvious choice for the smaller works executed in the artist's London studio after 1969. In the vertical *Quaver* King seems to have created the antithesis of *Crest* which skims the ground in a horizontal glide. For all its complex interaction of parts *Crest* seems to have been constructed from one sheet of material and thus has an organic feel at odds with that of *Quaver* which cheekily asserts the fundamental unlikeness of its components, through contrasts of colour, shape and arrangement. Where one seems to have evolved from the continuous adjustment of a single form, in the other the process is additive and disjunctive.

Diversity and tension constitute the basis of coherence in this sculpture and the source of its pert mood. Since the groups of elements have been pivoted through 270 degrees around an apex, stepping away from it in serried repetition, it is only possible to view certain clusters from any one angle. Contradiction also lies at the heart of the colour relationships: the smallest, lightest components bear the deepest hue, while the three colours together refuse to subordinate themselves to any over-riding harmony, maintaining a formidable independence.

In *Quaver* King returns in paradoxical fashion to the question of the pedestal. The base has not been reintroduced to segregate forms into an ideal space removed from that of the spectator, for the purple elements casually step off it to rest lightly on the adjacent ground. It is thereby divested of its traditional function and incorporated into the morphology of the sculpture. *Quaver*'s engaging fantasy derives largely from this wealth of visual punning and delight in contradiction which also appears elsewhere in King's work, as seen in *Tra-la-la* and *Shiva's Rings*.

21

Green Streamer 1970
Steel 112 × 116 × 363
The Trustees of the Tate Gallery

Edition of two:
Tate Gallery, London
Museum of Modern Art, Toyoma, Japan

Developing issues first explored in *Reel, Green Streamer* now interacts with its ambience in a more complex manner. In place of the prancing circular movement of the former it bunches up, tensed and flexed, momentarily poised yet ready to spring. This vitality is suggested by the way in which concertina elements fold back on each other, their dipping, arching contours overlapping.

Although *Green Streamer*'s character is far removed from the playful personages of the early sixties, animation remains an essential ingredient in King's approach to sculpture, albeit now in a new guise. By means of kinaesthetic empathy the interaction of the elements recalls aspects of our experience. This is very different from, for example, the biomorphic naturalism of *Drift* or the personage aspects of *Genghis Khan*: King has evolved a more abstract notion of animation and identity than hitherto. The central part of *Green Streamer* was made from a single sheet folded in three, then curved and cut diagonally and opened up like a concertina, the forms shifted apart to support each other.

Crucial to both the vitality and the particularised identity of the sculpture is the fact that King does not use preformed industrial parts but individually tailors his components: the spectator senses that the edges have been drawn rather than industrially fabricated. The brushstrokes applying the green paint have been adapted to the shapes of the forms, imparting a 'natural' feel to the sculpture and thereby enhancing its liveliness. When working with large sheets of coloured paper in his papiers découpés, Matisse spoke of 'cutting into living colour'. Since King's shapes are also handmade, form and colour seem inseparably linked: shape is colour, the colour the shape and not a skin or coating.

> Perhaps it is because I am playing with the idea of surface as skin, that is something evenly spread as a covering, that colour works well in sculptures like *Green Streamer*. (9)

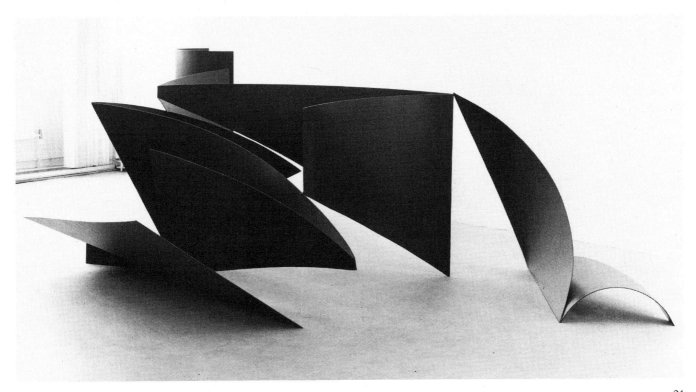

21

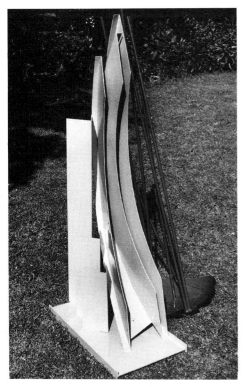

20

22
Red Between 1971
steel 183 × 457 × 457
metallic dark red, gloss
University of Liverpool

23
Sculpture '71 1971
steel 103 × 640 × 640
Rowan Gallery, London

Quaver is the harbinger of this principle of sorting elements into groups of like forms but now these various bundles intersect in a far looser structure with a less conspicuous sense of arrangement. The parity of scale between viewer and sculpture means that *Red Between* cannot be scanned but must be circumnavigated. But compared with works like *Reel* in which space unfolded continuously, in *Red Between* space has been moulded into contrasting and isolated pockets. Since the major viewpoints are now discrete, the spectator's experience of the sculpture is one of a collage of diverse spatial units:

> The name *Red Between* came because the eye finds it difficult to focus on any shape for very long, it is always thrown onto the next one. The experience is like being in between things in a shifting order, in which one hopes however to feel the full satisfaction of grasping something tangible. (11).

In this cluster of intersecting forms it is difficult to disentangle the structural relationships, for one sees not individual components but clusters of forms. In contrast with his previous formal clarity and structural legibility, King introduces a new intricacy and casualness of design. This was partly generated by changes in working procedures. *Red Between* did not evolve from ideas first sketched out in the form of drawings or rough models but was made from found forms, that is, from standardised parts lying around the studio, which King began toying with, testing out various combinations. *Red Between* received its name from the way in which pools of colour seem to collect in the interstices between the elements:

> In this work one of the more conscious aims was to use bunches of shapes in the same way that one might strike a musical chord where notes sound simultaneously. I wanted to avoid making tunes where notes are struck one by one and thereby avoid dwelling on shape and the sequence of parts and move towards more simultaneity, contrast and chance relationships. (11)

Red Between thus introduces new components, processes and formal qualities but they were hard-won. This sculpture was made in two stages separated by a period of almost two years. In the interim King executed *Blue Between* and *Yellow Between* which employ a similar morphology to effect different spatial experiences. All three take on an architectural aura rather than an animate organic life, owing partly to King's use of impersonal, industrial elements and to the procedures involved.

Sculpture '71 received its debut, and title from an exhibition held at the Royal Academy in January 1972, entitled *British Sculptors '72*. The Academy, assisted financially by the arts council, invited twenty-four participants each to execute a new work for the show. This ambitious enterprise, instigated by Bryan Kneale, was a tribute to the high international standing which this generation had attained for British sculpture. King had originally intended to submit *Blue Between* but circumstances caused him to change his mind and quickly finish this piece instead. *Sculpture '71* was subsequently modified: the centre was cut out and replaced with rust-coloured mesh, and its height was slightly increased. These changes centralise the work, emphasizing the core yet at the same time increasing its inaccessibility: *Sculpture '71* gains a resonant heart.

Since 1969 King had had not only a larger working area at his disposal and a studio well-equipped for working steel but the spacious concrete terrace immediately outside the studio gave him the opportunity of working outdoors in full view of the adjacent fields. On first glance, the horizontal extension of *Sculpture '71* is unfamiliar in King's oeuvre, yet it is the direct outcome of exploring certain ideas tackled previously from a different angle. King describes it as

> A variation on the earlier Brancusi like attempt to gain verticality through leaning. All the shapes stand up by being pushed up on three or four sides. (9)

Questions of gravity, mass and structure are here afforded explicit attention despite the focus on the centre which is physically unreachable and attainable only to the eye. The dimensions and scale of this work are experienced in literal terms by the observer who pits himself against the sculpture in a vain attempt to penetrate its inner core.

23

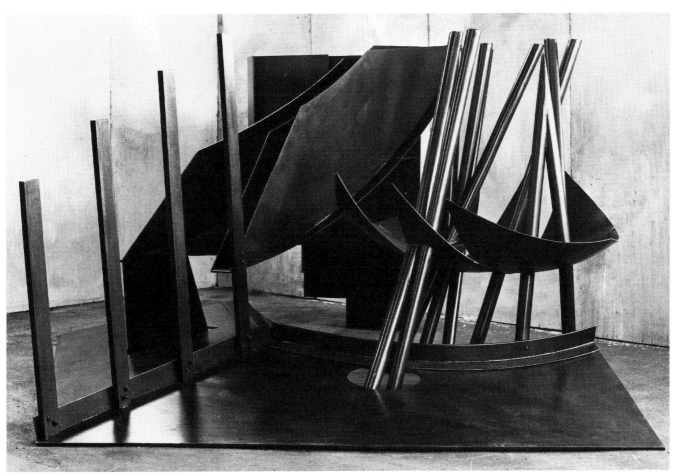

22

24
Ascona 1972
steel 231 × 457 × 457
darkish silver with purple tone, gloss
Collection Ulster Museum, Belfast

25
Open Bound 1973
steel, aluminium and wood 168 × 366 × 366
Kröller-Müller National Museum, Otterlo

Although King began using steel in 1968 with *Reel*, he feels that it was the experience of working intimately in a factory in Japan in 1969, for the construction of *Sky*, which played the crucial role in forming his attitudes to this material. He regards *Sky* as the first use of steel in his oeuvre in which no other material would have done, for nothing else would have had such tensile strength on a massive scale.

Whilst in Japan King became fascinated by Zen teahouses and gardens in which he was particularly struck by what he felt was a combination of crude materials with a highly sophisticated sense of proportion. This experience contributed in a general way to a new consciousness of materials that contrasts with his earlier belief in the necessarily neutral role of material. The works of 1968–9 in sheet metal (sometimes steel, occasionally aluminium) made no significant distinctions between the two materials. He only solved his suspicion of the indirectness of working metal by setting up a factory situation within his own studio and acquiring the necessary techniques himself, so that he could work directly with these materials in a manner which he regarded as analogous to his earlier habit of modelling.

Ascona has a new finesse and elegance in finish and detailing. It borrows its formal vocabulary from *Sky* and *Blue Between*, fusing the gesturalism of the former with the quasi-architectural aspects of the latter. This architectural quality stems from the size ratio of sculpture to spectator, for it invites the observer to identify the forms and spaces of the sculpture with his use of aedicular space. The parameters of *Ascona* are mapped out by the rectilinear elements which define a cubic zone within which the curving sheets and arcs create a continuous spatial movement, whilst the shiny surface enables light to break up masses and lend them movement.

Originating in a private commission King began *Ascona* for a site which contained a house by Marcel Breuer and a waterfall. The conjunction of severely rectilinear with fluid forms may therefore have been in part prompted by this location. *Ascona* hints at the way in which diverse experiences may be subsumed into a given language of form:

> I felt a need to contain the work and tie the work in together, whereas working with *Sky*, I had been trying to expand it and open up the interior space ... *Sky* was like a coiled spring with the tension held by the points touching the ground and embedded in concrete, the same problems of held-tension cropped up in *Ascona* but the tension got held within the work itself and there is no need to bolt it to the ground – the tensions balance themselves out above the ground. (11)

Certain differences between these two works have been conditioned by differences in their prospective sites. For *Sky*, at Osaka, King chose the largest area available, a vast empty space which required a vigorous extroverted statement. The domestic nature of the commission for *Ascona* inevitably imposed other considerations although in the end King developed the work in directions which made it inappropriate for the site, and the commission was relinquished.

This sculpture is unusual in King's oeuvre in relying extensively on preliminary drawings. Yet in many respects it marks the culmination of issues explored previously. Like *Reel*, *Open Bound* encloses space by means of a continuous circumference, but in contrast to the encircling movement of the former, *Open Bound* has a static, hieratic symmetry. This forces a return to a single dominant viewpoint, and produces an accompanying mood of contemplation rather than of ebullient physical engagement. Like *Red Between* it approaches the question of place in a quasi-architectural manner. With *Sculpture '71* it has an inaccessible core, a precious kernel, yet this arena now has architectural dimensions and associations. Physical entry is prohibited: only the eye and mind can penetrate the mesh.

A desire for some form of imaginative penetration led King to devise a second, small component which must be viewed independently:

> I think I felt in making that sculpture (the additional piece) as an idea in my mind I would have liked to have it suspended and transparent in the middle, there and not there. This sculpture (the main part of *Open Bound*) was around nothing. One always ended up with the void. I wanted to try to end up by going into it. (5)

The process of holding and contrasting these two disparate elements in the mind endows the interior space with an immediacy and actuality it might not otherwise have. This procedure revives an earlier notion, that the act of making connections may be a mental one for they may still be incomplete at the perceptual level.

Open Bound was redevised in *Open (Red-Blue) Bound*. Having agreed to a film being made of his work which was to include some footage of the artist working, King began to feel that the exigencies of the project made it more appropriate to explore some of the issues faced in *Open Bound* in new directions rather than to embark on something completely different. This explains the fact, rare in his oeuvre, of two similar sculptures.

Although closely related in certain respects, these two sculptures vary in significant ways.

> *Open Bound* is self-involved – things happen within itself as in a monologue: the spectator is allowed to listen in. The gaps are not inviting but self created like in nature. In *Open (Red-Blue) Bound* the work is outstretched to the requirements of the spectator. Visibility becomes a more important factor. Things come up, move forward or recede, to and away from the eye of the spectator. It is closer to the spirit of *Reel* for instance. (9)

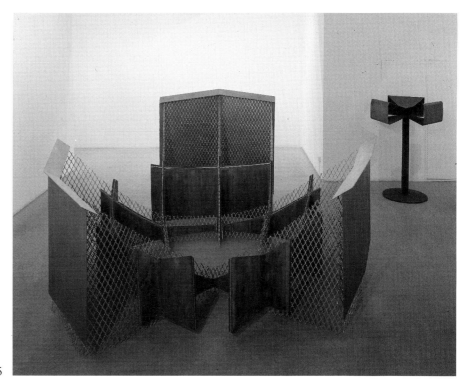

25

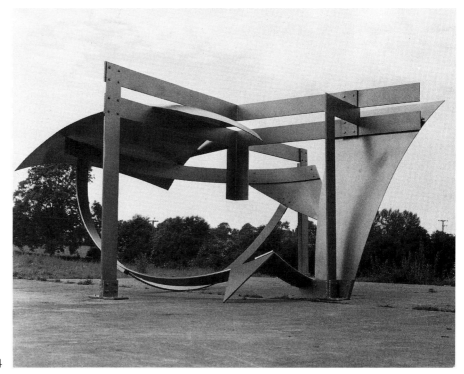

24

26
Angle Poise 1973
steel 99 × 386 × 91
Rowan Gallery, London

27
Wall sculpture 1974
aluminium 134 × 55 × 20
Collection of the artist
Edition of six:
Scottish National Gallery of Modern Art, Edinburgh
Arts Council of Great Britain
Private collections, London
Government Art Collection
Private collections, London
Mrs Lillian King

Angle Poise is a low, dark metal object whose main forms, anchored at each end, stretch horizontally to hover dramatically above each other in imminent union. The lever below seems to be a handle which could effect this junction if moved, yet shifting it would throw the various base forms out of alignment. Thus attempts to bring about this union can occur only in the mind for there are internal contradictions in the sculpture: *Angle Poise* suggests possibilities which cannot be realised in actuality. Although the main constituents are of a very different ilk – right-angled sections to one side, triangular ones opposing them, they promise to fuse if joined, whereas in fact they could only intersect. The end forms have been carefully attuned to these linear forces, with box-like forms at one extremity contrasting with the sharp-angled visor at the other.

Angle Poise is an anomaly in King's oeuvre: this self-enclosed sculpture, low in height and centred on linear forces has no precedent. The main viewpoint concentrates on the dramatic tension of these poised elements and the viewer assumes the role of passive observer of the object absorbed in its own activity. Its behaviour, together with its sleek finish, give it a mechanistic rather than organic flavour, also rare in King's work. The title possibly derives from the adjustable lamps yet surveillance television cameras and other swivelling appliances are perhaps also relevant. But such associations only enrich an understanding of the character of the sculpture, they do not pin it down in literal terms for the nature and complexity of the internal relationships are peculiar to it:

> A mes yeux elle doit éviter toute allusion ou évocation précise ou symbolique et se présenter comme une expérience à la fois distincte et directe.

Angle Poise marks the end of an era in King's work, one which culminated in a large retrospective at the Kröller-Müller Museum in Otterlo in 1974. In his next piece, *Sculpture '74* King did not pursue this foray into linear extension but instead turned in the opposite direction, reverting to a monolithic format.

The small size of *Wall sculpture* implies a substantial change in King's attitude to the question of scale, for previously he had always employed it to effect a physical contretemps between spectator and object; the dimensions of *Wall sculpture* would however seem to preclude this habitual mode of engagement.

> At one time I wanted to be directly, physically, involved with the work … changing the scale meant a new relationship with the smaller work … the only possibility was a manipulative one. (9)

He saw manipulation as the means to forge a new kind of engagement between the intimate object and the observer, an idea that had precedents in the work of Caro:

> Caro had talked a lot about handles in his work … I experienced it in a similar way. (9)

During the period following King's return from Greece in 1960 in which he was searching for a way to realise his new vision of sculpture, he had utilised motifs like the ladder and the window, familiar objects whose form and scale had been determined by man's relationship with them, as found in *Window piece*. When considering the possibilities inherent in small scale sculpture, King reverted to his earlier approach by again starting with an ordinary object whose size, proportions and articulations were familiar to him as the basis from which to proceed. The central rectangular element in *Wall sculpture* comes from a wooden frame which King knew from his childhood when it was used as a doorstopper. His familiarity with it gave him the license to annex it. He then began to incorporate elements of a similar size around it in an improvisatory manner for he felt he had to learn afresh his relationship with objects of such modest scale.

Caro's great admiration for Picasso's relief constructions may have initially stimulated King's interest in these works, but it is typical of King's approach to sculpture that he should seek the forebears of any mode or genre that he adopts. In *Wall sculpture* there is an overriding concern for the literal and tangible presence of the sculpture as object not found to the same extent in Picasso's works. By means of an emphatic contrast between the components and the multi-axial arrangement, *Wall sculpture* destroys any vestiges of a rectilinear pictorial format and a two-dimensional surface. This vigorously oblique alignment of elements shatters traditional tendencies to a vertical/horizontal disposition. In its assertive contrasts, asymmetrical grouping, and assemblage technique *Wall sculpture* presages changes soon

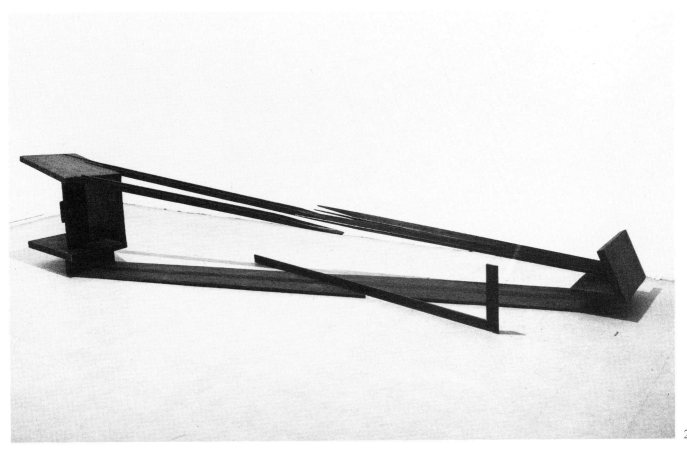

26

to occur in King's large scale work and exemplified in *Sculpture '74*. In terms of a small scale format *Crest* extends this interplay between components and the multi-axial movement into a fully three-dimensional context.

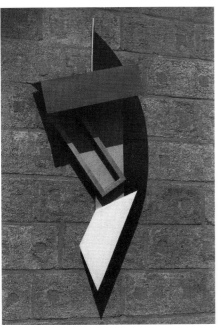

27

28

Sculpture '74 1974
concrete, steel and steel mesh 254 × 315 × 176
Rowan Gallery, London

In *Sculpture '74* King pursued his interest, first seen in *Sculpture '71* and *Open Bound*, in combining several different materials within one work: new, however, is his decision to leave them in their raw state. This resulted partly from his desire to work more directly and spontaneously; he also began to include found objects for the same reason. In *Sculpture '74* King affirms the mass of his forms in a forthright manner without equal in his work to that date. For the first time mass and volume have been simultaneously asserted, and he employs an emphasis on texture to this end where previously he had sought smooth coloured surfaces which promoted the planar quality of forms. Yet King realises his new priorities in a surprising manner and one which confounds conventional expectations about monolithic sculpture. In readmitting certain traditional qualities, he vetoes others. Although tending toward the monolithic in format it has been constructed by assemblage methods: *Tra-la-la* provided a prototype for this conjunction of unlike forms. For *Sculpture '74* is no longer a self-contained entity with a simple clear contour: the triangular wing perched precariously to one side apparently in defiance of gravity asserts that the unity of the sculpture is not organic but man-made. The limpet-like girder sections ostensibly affixing the cumbersome triangle to the smaller rock appear too numerous to be merely functional and too insistently different in material to subsume themselves to a purely auxiliary role: they stress the unexpectedness of this conjunction of diverse parts. King describes *Sculpture '74* as:

> The nearest thing I have done to a collage technique. There are three separate parts [each] of a different order of experience. The way they are linked is crucial: it had to be poised exactly between something practical and natural without losing the element of something just being held there in sudden juxtaposition. I tried for instance to have only one arm for the open box, but it would have looked like an arm and lost the dematerialised aspect of the box. (9)

Sculpture '74 manipulates space in multiple ways: it bounds space with planar forms in the smallest rectangular element projected from the mesh; it contains yet leaves its movement fluid by the use of mesh; it displaces it by the solid granite object; and it interacts with it by the way in which the sculpture as a whole acts within its milieu. These complex formal, spatial and textural contrasts introduce a note of Baroque richness reminiscent in spirit of earlier works like *Genghis Khan*. Although *Sculpture '74* marks a telling shift in King's work in formal and material terms, his oeuvre as a whole is remarkably diverse. He has no obvious signature style such that his sculptures are immediately recognisable as works by his hand. In place of a stylistic consistency, there is one of aesthetic conviction.

29

Brick piece 3 1975
brick, steel, steel mesh 51 × 40.5 × 30.5
Mrs Belle Shenkman

Brick piece 1, 2 and *3* introduce new directions by their concentration on two main ingredients, a block of solid matter and a triangular piece of mesh. All are on a small scale and are composed on the principle of contrasts, which serves to highlight the disparity amongst the components. *Brick piece 1* juxtaposes the volume of the rectilinear brick with the opacity of the triangular mesh and the planar metal sheet which resembles an unfolded piece of paper. The tensile strength of this bent sheet opposes the inert lump on top of it whilst the mesh hovers playfully above. Further contrasts are explored in *Brick piece 2* which introduces a linear form in place of the planar sheet. In *Brick piece 3* the mesh acts as a foil to a sort of angular table top.

In each sculpture the clarity of composition enhances the lively complexity of relations amongst the parts. *Sculpture '74* developed out of this repertoire of forms, for King began with a notion similar to *Brick piece* but then sought new possibilities

In *Brick piece 3* the jauntily cantilevered mesh acts as a foil to the stolid brick, whilst the fulcrum below, a metal plane, seems forced to an extreme angle in order to balance these disparate components. This forceful contrast amongst the elements, together with their dramatic positioning, gives *Brick piece 3* its dynamic vitality.

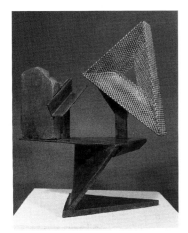

29

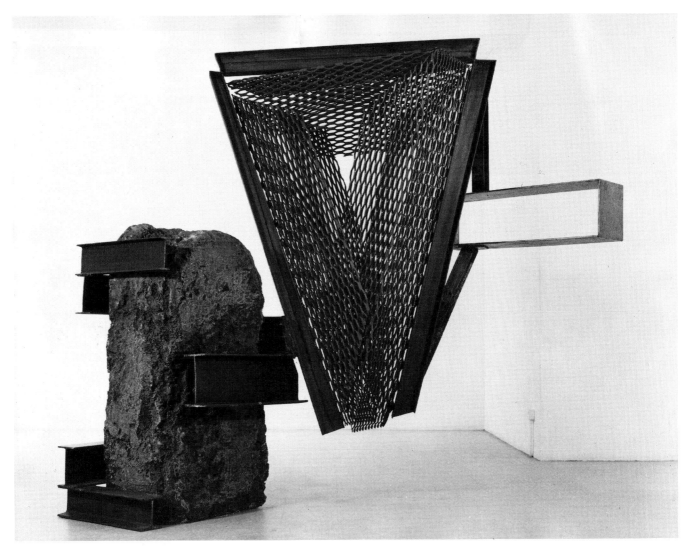

28

30

Open Place 1977
steel and slate 131 × 233.5 × 269
Rowan Gallery, London

In contrast to *Sculpture '74,* *Open Place* shows a severe reduction in formal and material syntax, for its repertoire has been limited to steel beams and slabs of slate, variously slotted and abutted. Although fundamentally cubist in derivation, *Open Place* is fully three-dimensional for interior space is moulded as exterior space is vitalised. This sense of space is plastic and physical rather than ideal. Where previously in King's work inner and outer worlds were segregated, as in *Reel* for example, or the distinction was rendered non-existent, as seen in *Brake,* now the two achieve a limited interaction. The cubist principle of hinging planes from a linear scaffold or armature is used paradoxically in *Open Place,* in that these planes enclose an interior space rather than opening out a solid form in order to integrate the object with its ambience, in a planar reading. By creating a concealed spatial core *Open Place* denies that interaction of plane, solid and space which formed the raison-d'être of cubism.

It is typical of King's complex approach to sculpture that the morphology may resemble cubist precedents at the same time that the structural principles are resolutely sculptural in heritage. In this respect *Open Bound* parallels *Declaration,* though now the forms move around a spatial cell.

> *Open Place* by contrast to *Sculpture '74* is made like a wall stacked horizontally – each part encased by its neighbour. It started on the left (at the large vertical slab) and moved to the right and back again on an elliptical path. (9)

The interaction between interior and exterior is restricted in that it is open to visual rather than actual entry. The core is now demarcated by substantial matter rather than by thin planes as had been the case with much of King's previous sculpture, including *Reel* and *And the Birds began to sing.* Recognition of the mass of these slabs depends very much on a strong assertion of textural rather than surface qualities. The natural material is no longer concealed beneath an applied skin of colour for the inviting tactile warmth of slate and its inert density of colour are integral to a recognition of the weight and substance of these slabs. The sensual beauty of material and stable balance of low, earth-hugging forms contributes to the creation of a sense of place as sanctuary or refuge.

31

Rock Place 1976/7
steel, steel cable and slate 91.5 × 85 × 85
Private collection, Antwerp

Rock Place shares with *Shiva's Rings* the use of disparate elements in an unexpected configuration, but where *Shiva's Rings* creates a composite image from the accumulation of diverse components, the opposite is the case with *Rock Place.* Here the multiplicity of elements and materials has been subordinated to a dominant image whose legibility ensures that it creates an immediate impact. *Rock Place* is more restrained in mood than its complex counterpart whose forms are held in vigorous tension: *Rock Place* has a ceremonial presence. The large slab of slate is borne like some precious cargo by its supporting form whose curved base seems to carry effortlessly the full weight of this burden. The cable below, encircling the whole, suggests pools eddying from the central image at the same time as it designates the resting place of this crude shell bearing Aphrodite. The small steel piece, suspended from the cable girding the slate, acts like a prow or piece of armour protecting the vulnerable member behind. The emphatic securing of this upright form by wire hawsers, suggesting that the prize has been forcibly ensnared, encourages an awareness of the high value of this captured object. Multiple if allusive associations, reminiscent of journeys, sacred sites and ritualistic objects, imbue the sculpture with an aura of potency and mystery.

It is indicative of King's approach to sculpture that such associations arise out of a formal exploration of the object, they do not precede and condition the image. As he adopts different materials and working procedures different kinds of experience are drawn upon, although the fundamental aesthetic precepts remain constant. This may be demonstrated by a comparison between *Quaver* and *Rock Place.* In the former the combination of physical lightness in the elements with their impersonal finish and vivid colour eliminates specific associations to the external world in favour of more abstract relationships. By contrast, the combination of various materials in a crude state with a forthright affirmation of mass gives *Rock Place* an assertive physical presence. Together with the individualistic nature of its main form, the slate slab, this localises its references firmly to experiences in the material world.

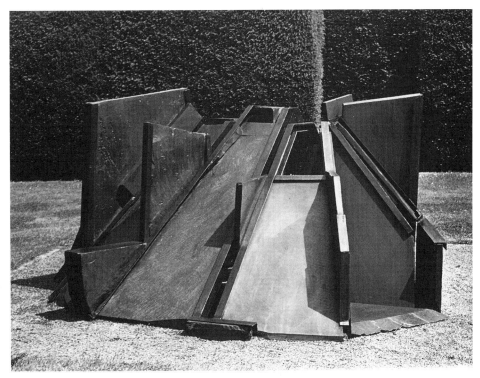

30

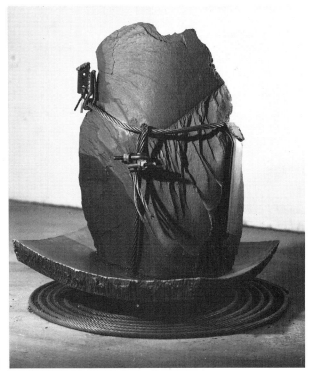

31

32
Tracer 1977
steel, rope and slate 76 × 64 × 56
Rowan Gallery, London

In the context of the group of sculptures made with these materials *Tracer* has a unique compositional structure: an open skeletal combination of simple forms. Devoid of any core, these rudimentary shapes have been separated out from each other and suspended in tension by the cable. Its linear nature also acts as a guideline for the eye, providing paths for an exploration of the sculpture whose diverse components and centrifugal activity give it a constantly changing and elusive identity. The edges of planes are rarely aligned but intersect at sharp angles in scissor-like activity; all the elements have been vigorously tipped away from the horizontal, so none sit firmly on the ground. *Tracer* is poised for imminent take-off. Apparently only temporarily earthbound it suggests some projective capable of cleaving through space.

King seeks to give the composition an organic coherence, to forge an internal unity so that it becomes more than the wilful contrast of diverse units in space. This is achieved partly by finding an analogue in experience for the activity and interrelationship of the parts. Their behaviour, if not their appearance, seems familiar rather than wanton as the spectator gradually discerns the logic of their activity: the rudder-like form is balanced against the spine of the sculpture, an oblique mast. The ballast given by the small cylinder cantilevered to one side also contributes to this equipoise. Yet these connections seem flexible rather than fixed as if the forms are constantly readjusting themselves to the pressures of speed, motion and function. Such behaviour may not be organic in the sense employed in much of King's earlier work, yet it is convincingly natural, and thus *Tracer* adheres to his ideal of sculpture as man-made, parallel to nature yet not imitative of it.

33
Bali 1977
steel 180.5 × 233 × 355
City of Antwerp, Openair Museum for Sculpture, Middelheim

Notwithstanding its kinship with cubist precedents, *Bali* is a singular, even iconoclastic sculpture. Although it has a spine, like the assemblage reliefs of Laurens for example, which fan out into space along this axis, King has tipped the spine horizontally so that it becomes a kind of backbone along which the other forms and linear vertebrae have been splayed. *Bali* becomes an animate thing that sways and lurches beetle-like through space. King has compared its movement with that of bellows, and this contraction and expansion of elements at different points within the whole largely accounts for its organic character. This animate being is far removed from the neutral, static objects which are most cubist sculpture. Nor is *Bali* fettered by any adherence to a pictorial aesthetic; not only does it occupy and vitalise its considerable ambience but it demands a variety of viewpoints.

In *Bali* King reverts to the anonymity of industrial materials found for example in *Red Between*, but whereas that sculpture was composed of grouped elements, the disciplined movement of forms along the spine of *Bali* is new in his work. King's sudden return to the use of opulent hues and an applied skin of colour reflects his iconoclastic attitude to contemporary dogma. King had abandoned applied colour as unwarranted when he began using found steel parts rather than components made from newly forged plate: the incorporation of several different materials within a single sculpture had also opened up the possibility of contrasting natural textures and surfaces. Meanwhile the addition of colour in steel sculpture had become generally regarded as taboo, so King decided to re-introduce it into *Bali* in order to demonstrate the absurdity of axiomatic truths of this kind. Its luxurious burgundy coat also enhances its exotic character.

In King's recent sculpture, characterisation had largely concerned itself with place, that is, with a sense of physical and mental location. However, in *Bali* this preoccupation is momentarily laid aside in favour of his earlier conception of the object as an organic creature who intrudes into the spectator's world.

> At the same time it requires an engagement with each of several sections which in turn solicit the observer's attention as they pass in front of him. (9).

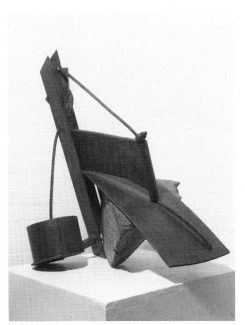

32

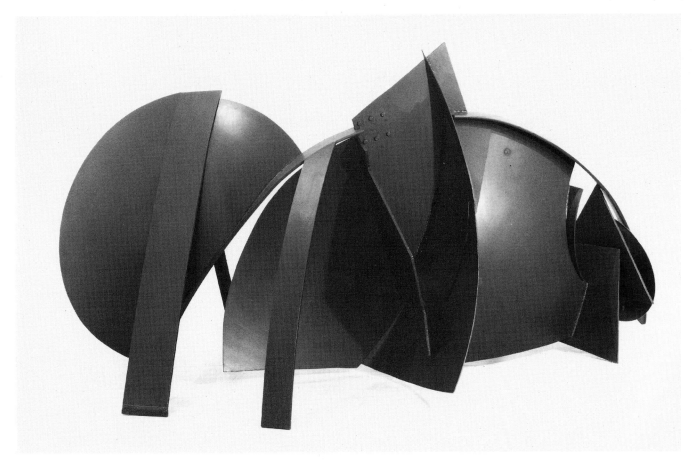

33

34
Ring Rock 1978
slate, steel and lead 91.5 × 66 × 66
Lily Modern Art Gallery, Jersey

A bouquet of slate forms gathered together in a taut metal holder, *Ring Rock* at first seems very different from other works of this year, yet it reflects similar ideas. King's preoccupation in the cones of the early sixties with volume but not mass has now been reversed to emphasise mass: the weight and tangibility of the form dominate so the angular steel handle with its invitation to life becomes almost a wry gesture. The small scale of *Ring Rock* is still carefully geared to the spectator, albeit in ways very different from *Crest*, and other works of like size. Whereas the twisting and manipulating of malleable stuff lay at the heart of *Crest*, now the actions of the hand grasping and loading solid matter are more evident: yet both sculptures affirm one of the central tenets of King's aesthetic, expressed as early as 1961:

> In my work the effort to create a work that involves *me* as a starting point, the classical idea of the creator, the individual creator at its simplest, is a physical involvement (action painting) and tends to make me work on a human scale. (5)

Territorial demands, whether those of an object requiring its own breathing space or an architectonic construction defining its perimeters, continue to preoccupy King. Works like *Ring Rock, Rock Place, Open Place* and *Sculpture '74*, and some of their titles, point towards a manner of defining or designating a particular location quite different from King's earlier procedures. Previously it was the actual activity of demarcating which was emphasized; in these works the mapping out has long passed, the sculptures appear to be the result of former deeds. Now the allocation of significance to a site carries an atavistic quality largely on account of the use of materials in what is apparently, if not actually, a raw or natural state. Although *Span*, for example, had overtones of archaic precedents, as did, though in very different terms, *Open Bound*, the present group of works appears more earthbound, tranquil and static. They tend to be inward-turning in character and dense, stable and solid in form, encouraging a contemplative mood in the observer. This may reflect King's increasing involvement since 1975 with meditation. Although it has not caused a change in his aesthetic ideals it may have contributed to the growth of a more subdued aura in these works, in place of the nervous tension found in many earlier sculptures. With the realisation that self-knowledge may evolve from a renunciation of searching, something of the former urgency of the sense of striving has disappeared:

> I feel the first and most important effect of meditation on the artist is a general move towards more positive values and away from anxiety and depression … I cannot say it has radically altered basic aesthetic considerations, the same ideals exist before and after … (14)

35
Shiva's Rings 1978
steel, slate and wood 150 × 114 × 76
Arts Council of Great Britain

The idiosyncratic character and zest of *Shiva's Rings* springs from King's delight in juggling complex and diverse components into a fanciful if formidable combinations very much at odds with the statelines of other recent pieces, such as *Open Place*. The centrepiece, around which the other components seem precariously balanced, suspended and hinged, is a slate slab curiously peppered with holes: this is a found piece pierced with trial holes made by quarrymen sharpening their tools in readiness to excavate the slate. Anchoring the slate to its curved base is a battery of bolts and cables, far in excess of structural requirements. Additional bolts, leading nowhere, assiduously plug other cavities. Above this, a weighty stone is harnessed to a steeply angled plate which reclines recklessly on the upper edge of the slate slab. This configuration of visual puns is held upright by a steel spine which acts as a supporting stanchion, and bends under the weight, real or imaginary, of its load. The bravado with which this plethora of forms and materials has been synthesized gives an extraordinary vitality to *Shiva's Rings*, yet this complexity is just held in check and does not subvert the coherence of the whole:

> For me this was something new and spontaneous. For the first time I was using wood and much of the work happened subconsciously, so it may be seen as machine-like or as some devotional object – an Indian sandal, a foot or a dagger. (15)

King's excitement occasioned by the use of new materials has been retained in the wit of the final image.

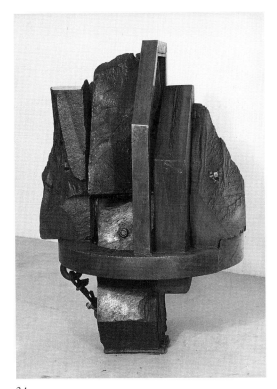

34

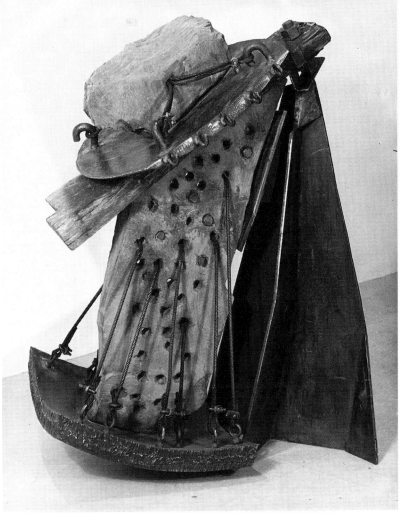

35

36
Maquette for Cross-bend 1978
steel 108 × 118 × 63
Collection Christopher Todd

King views commissions as a challenge yet they are not something with which he wants always to be involved for he feels that they tend to force the artist to work retrospectively, to look back over his previous ideas rather than to attempt something completely new. The challenge of dealing with the architecture and the site replaces the freedom and openness of the studio. King finds attempts to execute commissions directly on the site, from scratch, to be 'brave', yet he argues that it is impossible to recreate the studio situation elsewhere. Thus he prepares maquettes for such works with considerable care.

This maquette was one of two which King entered in a closed competition for a tiered site located outside the European Patent Office, the largest building in Munich. One of the many problems involved in the commission was the reconciling of the multiple factors of cost, materials, logistics and technology. The final work, thirty-five feet high and forty-five feet long, was made in mild steel blasted back to its pristine state then sprayed with hot zinc to produce another skin for long-term protection against rust; this was finally coated with a light-bronze colour overcoated with other colours to give it a pearlescent sheen. King chose this shade to create a warm contrast with the cold gray of the adjacent building, not to simulate another metal.

A major factor of the site was the multiplicity of views it afforded of the sculpture, from various heights and both within and outside the building. *Maquette for Cross-bend* takes on a dynamic identity commensurate with this variety of angles. Multi-axial, it twists through space as it arches from the terrace to the forecourt below, steadied and anchored by the stable low-slung diamond shape behind. With its springing organic movement in sharp contrast to the severe and static facade of rectilinear forms, *Cross-bend* effects a radical transformation of this exterior space.

37
Snake-rise 1979
steel 183 × 244 × 152.5
Rowan Gallery, London

Although *Snake-rise* shares with much recent abstract metal sculpture a repertoire of relatively small components of scrap steel, King employs these forms in a distinctive manner, and according to long-established precepts. It is the first of his works to have been made entirely from scrap metal for King did not incorporate any deliberately shaped components as he did later in *L'Ogivale*. Part of the reason for this lies in the unusual context in which it was executed, during a visit to Australia in 1979. The fact that he was working publicly, while teaching in an art school, and for a period of limited duration led him to operate in a new way. Since King sought to reveal as clearly as possible his intentions and decisions, the manoeuvres were articulated quickly in a very open way of working, one which he likens to 'thinking aloud'.

Although improvised, the final structure has an organic unity that recalls his previous modes of working, of establishing a sort of 'behaviour' for the sculpture. The sense of reciprocation of force and weight between the parts and various sections distinguishes King's ideals from a merely formalist procedure for the resulting relationships adhere to a broadly anatomical model, 'parallel to nature yet not imitative of it', as King phrased in 1960. In the late sixties, with works like *Quill* and *Sky* King achieved an almost weightless flow of forms through space. Beginning with *Bali*, but more overtly in *Snake-rise* and *L'Ogivale* a new kind of motion replaces his earlier concern for a fluid continuous dynamic. Now the sense of movement is more ponderous and intermittent as if the piece moved its various sections sequentially rather than simultaneously. This change is effected not only through the compositional structure (now more complete with subsidiary activities and parts) but also by the affirmation of the tangibility and mass of the components. Far removed from that streamlined linkage of one part to the next of *Quill* or *Green Streamer*, in *Snake-rise* major axes create an overall sense of propulsion which is modified or modulated by the smaller integers. Those few elements which make contact with the ground do so only along oblique edges, their position suggestive of immanent motion. Above all, the repeating circular profiles, both positive and negative, which rhyme like a leitmotif throughout *Snake-rise* enhance the impression of movement, their distinctive and bold presence helps distinguish it as a work by King. In contrast to the somewhat intermittent or circular activity in *Snake-rise*, the swaying arcs of *L'Ogivale* create a full bodied surge through space.

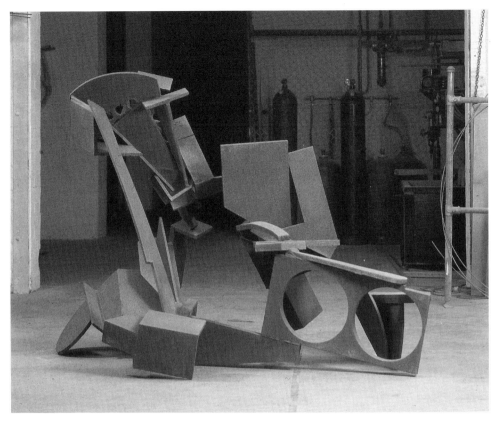

37

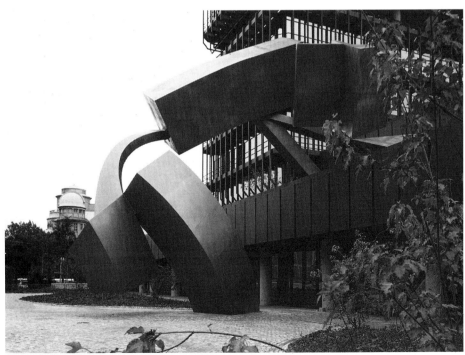

Cross-bend 1980
steel 1064 × 1368 × 760
European Patent Office, Munich

Within 1979
slate, steel and elm 218.5 × 292 × 241.5
The Trustees of the Tate Gallery

One of King's largest works to date, *Within* synthesises monolithic and cubist traits, drawing together two antithetical strains in recent sculpture. Since its massive piled components never fully cohere into a single compact form, it fuses the dual modes of sculpture which had long engaged King: sculpture made from forms that span space, and sculpture which is oppressively closed, as though in self-defence. Although in fact very heavy these large blocks of elm and slate have been handled so adroitly that they seem, to the eye at least, to rest lightly in place. Bodily or manual manipulation appears to have formed *Within*, rather than forklifts and other machinery. It feels anthropomorphically scaled, and avoids monumentality and rhetoric in favour of a jeu d'esprit. Confirming a statement King made at the outset of his career in 1961, *Within* attests to the consistency of his aesthetic:

> If one could imagine a simple physical gesture as being symbolic or representative of the total existence of man, it would surely not be lifting a small stone between the fingers but a large weight where the total human potentialities of the body were involved.
>
> The constructive effort is essential in the aesthetic experience, to give the starting off spiritual push. It is the beauty of the visual arts that 'matter' is one of the elements involved. Man is in touch with his heroic nature as well as reassured that the experience is real, palpable like his own body and not a freak of the mind. (5)

The feeling that *Within* has been compiled by man power is furthered by the way in which many surfaces have been scored or patterned. Potentially fussy if it were more obtrusive, this detailing dissolves at a distance. Traces of colour in less exposed places hint at the presence of an internal sanctuary, offering an invitation to penetrate.

The thirty-two interlocking chunks of slate, steel and wood scorn King's previous concern for clarity of contour and a simple compact image in favour of a more complex and dynamic interplay of parts around the sculpture. Although *Within* is markedly different in appearance from the works of that year King stated his involvement with its central issue as early as 1965:

> The concept of parts flowing, space held and pushing out is something I can't get away from and don't want to get away from. (4)

For the first time elm plays a considerable role in King's sculpture. These materials have been chosen principally for practical reasons, determined by economy in part, and although King concentrates on the sense of substance and tangibility in his forms he exploits textural contrast to clarify structure. Linear steel elements wrap and support the more bulky members: typically the slate is planar in form and cuts into or directs the flow of space while the robust chunks of wood attempt to cohere into larger units:

> I've twenty tons of elm waiting to be used. I need to work with materials I feel are beneficial – not unhealthy like fibreglass, which I found full of dust and which has a bad smell. But wood is warm and I enjoy using it.
>
> Steel is getting very expensive now, while slate and elm are cheap. I like to use materials that are easy to get hold of so I've plenty around and I'm not restricted to something precious. (15)

Despite the variety of materials King effects an organic unity from the way in which parts coalesce: a sense of erupting growth pervades the sculpture so that in the final orchestration nothing appears impromptu. *Within* suggests less a place than a state of being: stress and tension are integral to it, endowing it with a heroic dimension very different from the contemplative mood of recent sculptures like *Open Place*.

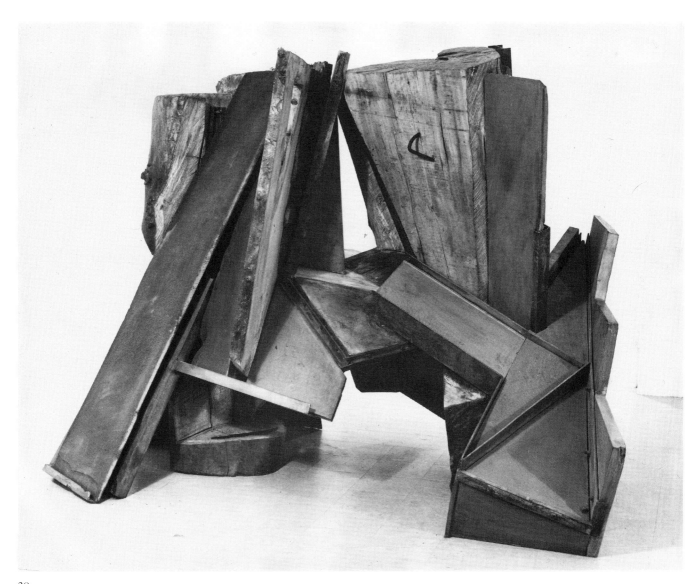

38

39
Shogun 1980
Wood, steel, chain resin $216 \times 254 \times 188$
Rowan Gallery, London

In an interview in 1965 King stated:

> The struggle of matter towards expansion, movement and change is set against an awareness of the static controlling forces of inert matter. Hence the often recurring use of the cone as a very large, very much earth-bound shape that will provide maximum challenge in an effort towards expansion. (2)

This comment was made with reference to *Genghis Khan* yet has relevance for *Shogun* and suggests that King's underlying preoccupations have changed little. Whereas *Genghis Khan* created a personage within which this activity occurred, *Shogun* is improvised and more abstract, paralleling a general change in King's work as a whole.

As usual the title was given after the completion of the work and offers a characteristically suggestive way of approaching certain of its facets. Its Japanese name recalls warriors, implacable and defiant. At the same time the sculpture's near-heraldic format has something of the form of a written character, for the rectilinear contours frame a gestural interplay of elements. In *Shogun* construction is analogous to modelling which has always lain behind King's approach to sculpture, for he works by accretion, adding and shaping form and space rather than beginning with a finite object and excavating within it as occurs with carving.

Shogun has two principal faces. Yet it is not flat, for a concern with plastic rather than pictorial issues still dominates King's approach to sculpture. The tangibility and plasticity of these components is undeniable. From the front the piece has weight, density and a restricted depth; by contrast, at the back a cavern of space in a shell-like zone has been created from the unlikely conjunction of rotted elm and steel. The vulnerability of the wood has been exploited formally without any accompanying sense of pathos. Despite the plethora of disparate components the overall configuration is architectonic, like a portal which is firmly barred by the internal jamming of forms. The heavy wooden lump clinging on the upper rampart stabilises the structure as well as the design, giving a sense of permanence to the contorted construction below. In places, King adds colour to the wood to minimise the differences in hue between materials and to harmonise them, but these accents of colour, wax and charring also enhance the ceremonial or presentational aspect of the work for they seem to belong to the history of the object as a whole rather than to the previous existence of any individual component. The unexpected addition of the metal chain gives an intimation of Shogun's quixotic character; its dammed up exterior conceals a more intimate or private zone behind. This element of surprise, which has informed King's work from *Rosebud* onwards, takes on a new guise in *Shogun* where the contrast of inner and outer is not effected within a volumetric form but in the opposing sides of a predominantly planar object. It enhances the drama and immediacy of the sculpture adding to the grandeur of confrontation:

If sculpture is purely 'in' the world, is Spatial Pictoriality or Pictorial Space what separates it in the same way that the pedestal used to? Or is pictorial space a denial of sculptural values like mass? Should the marriage of the pictorial and its opposite, graspability, be such that though married their separate existence is not denied so that they do not interfere with one another. The pedestal did this very simply by raising the sculpture above the world ... Sculpture needs a way of 'cohabiting' with the real ground plane ... Perhaps pictoriality *is* a way of making sculpture different from the world ... even a simple statement, this is not real – or this is art, is enough to create in our minds a role for us towards the object. (12)

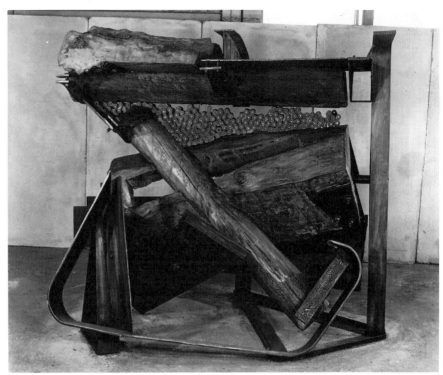

39

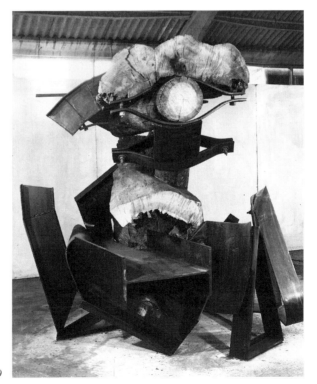

39

40
L'Ogivale 1981
steel 213.5 × 259 × 203.2
Government Art Collection

From 1974 King's works have been created intuitively from found forms and materials, parts are rarely fabricated. King scours scrapyards as the only cheap source of steel now available, preferring those with little turnover, where old and unusual pieces may be discovered. Yet these procedures have not shortened the time taken for the creation of a particular sculpture. Although the period of actual execution may have decreased, the 'getting acquainted period', or long intervals of contemplation needed in order to integrate and harmonise the work from all angles, cannot be similarly reduced. Working with found forms encourages chance permutations, provoking new thoughts and establishing new directions. It is an open-ended process which accords well with King's increasing dislike of the dogmatic and canonical in sculpture.

This abstract improvisatory method carries the danger of placing questions of texture or detail above the definition of form. Yet the organic and clarified object, however complex, must dominate the spectator's perception: the sculpture must be experienced as a convincing whole and not a casual, if pleasing, array of forms. This formal coherence must in turn be subsumed to the larger question of identity. As in all King's recent work, a preconceived image does not dictate the formal realisation, the identity must be forged during the making.

Being neither predictable nor familiar the sculpture makes a direct challenge to the spectator. The initial glimpse generates an expectancy or curiosity which encourages the observer to examine the object further, to render the unknown known, the hypothetical real: revelation is for King physically determined:

> The object we are exploring becomes part of our experience
> of ourselves: we see in it equivalences to our body experience.
> (9)

L'Ogivale is constructed partly from found forms; the arch, probably a piece of squashed piping, and the foot of a fork-lift dray have been incorporated with fabricated shapes into an organic whole. In the motif of the arch, the source of the title, King has introduced a form with particular references where previously he might have hesitated before using such a specific image in an abstract sculpture. He has moreover afforded it special prominence, in making it the focus not only of visual but of expressive interest. The straddling legs of *L'Ogivale* do not appear to bear down heavily on the ground despite the considerable weight of the sculpture: they rest easily and on few points. This lightness of balance together with the rhythm of areas intersecting at belly-height through the main body of the form imbue its activity with an aura of naturalness. A skilful differentiation between the sides and front and back of the sculpture enhances the impression that a single continuous movement links all parts of the work. The sculpture sways through space bearing its sacred object. In becoming an animate entity in this way, *L'Ogivale* takes on an identity.

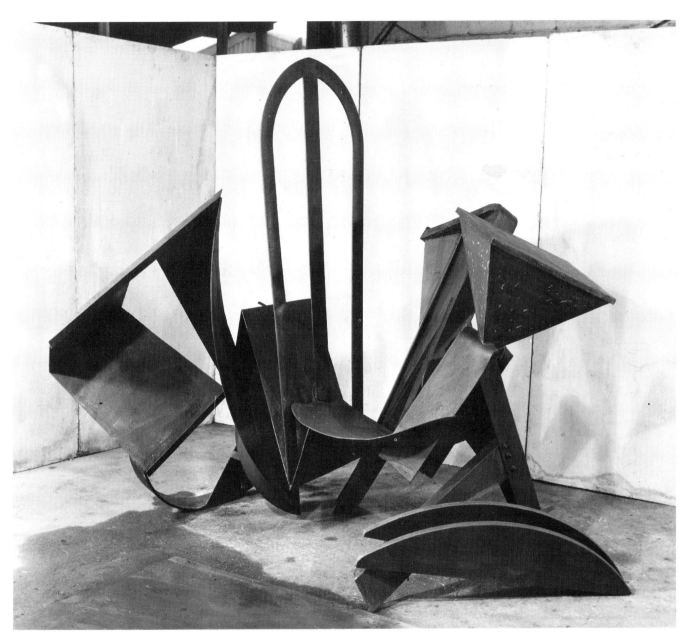

40

41
Clarion 1981
steel 517 × 608 × 456
Romulus Construction Company

42
Still life 1981
steel 76 × 76 × 45
Rowan Gallery, London

(These two works were incomplete when the catalogue went to press)

Sources of quotations

1 Norbert Lynton, 'Latest Developments in British Sculpture', *Art and Literature*, No. 2, 1964.
2 'Phillip King, Young British Sculptor working mainly in plastic answers some questions by John Coplans', *Studio International*, December 1965
3 Charles Harrison, 'Phillip King – Sculpture 1960–68', *Artforum*, December 1968
4 Phillip King interviewed by Charles Harrison, tape, Whitechapel Art Gallery 1968
5 *Phillip King*, Kröller-Müller National Museum, Otterlo 1974.
6 *Phillip King: Sculptures 1970–75*, 'La sculpture ou l'experience directe par Phillip King', Musée Galliéra, Paris 1975.
7 –, 'An Interview with Phillip King', *South West Arts Newsletter*, March/April 1976
8 *Primary Structures*, Jewish Museum, New York 1966
9 Conversations with author, March/April 1978; January/February 1981
10 Phillip King, Unpublished statement on the influence of Brancusi on his art, 1978
11 Lynne Cooke, 'The Sculpture of Phillip King 1960–72', unpublished MA Report, Courtauld Institute of Art, 1978
12 Phillip King, Unpublished Sculpture Notes, March 1978
13 Phillip King, Unpublished Notes 1979 (?)
14 Phillip King, Unpublished Notes for a Talk at Mentmore Towers, 1979.
15 –, Review of King's sculpture at Rowan Gallery, *Hampstead and Highgate Express*, April 6, 1979

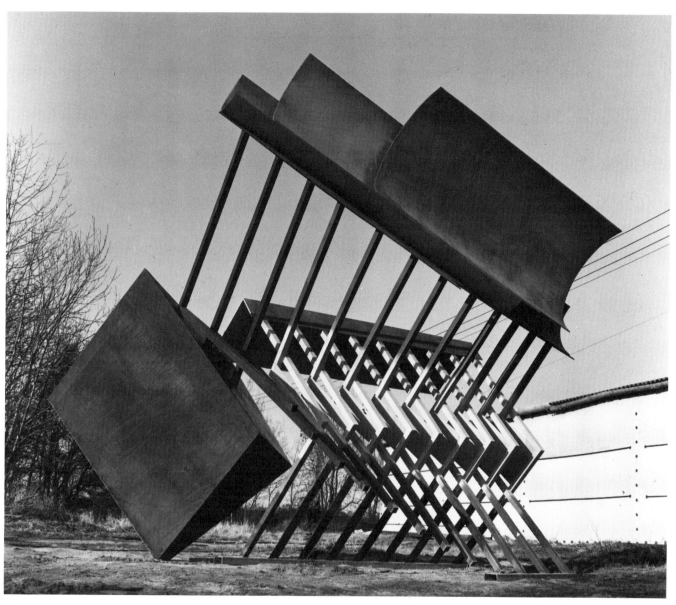

41

List of works

1 **Window piece** 1960–61

2 **Declaration** 1961

3 **Drift** 1961

4 **Rosebud** 1962

5 **Twilight** 1962

6 **Tra-la-la** 1963

7 **Genghis Khan** 1963

8 **And the Birds began to sing** 1965

9 **Barbarian Fruit** 1964

10 **Through** 1965

11 **Point X** 1965

12 **Slit** 1966

13 **Slant** 1970

14 **Brake** 1966

15 **Call** 1967

16 **Span** 1967

17 **Blue Blaze** 1969

18 **Reel 1** 1969

19 **Crest** 1970

20 **Quaver** 1970

21 **Green Streamer** 1970

22 **Red Between** 1971

23 **Sculpture '71** 1971

24 **Ascona** 1972

25 **Open Bound** 1973

26 **Angle Poise** 1973

27 **Wall sculpture** 1974

28 **Sculpture '74** 1974

29 **Brick piece 3** 1975

30 **Open Place** 1977

31 **Rock Place** 1976/7

32 **Tracer** 1977

33 **Bali** 1977

34 **Ring Rock** 1978

35 **Shiva's Rings** 1978

36 **Maquette for Cross-bend** 1978

37 **Snake-rise** 1979

38 **Within** 1979

39 **Shogun** 1980

40 **L'Ogivale** 1981

41 **Clarion** 1981

42 **Still life** 1981

Biography

Phillip King was born in 1934 in Kheredine, near Carthage. In 1946 he came to England where he attended Mill Hill School. In his second year of National Service with the Royal Signal Corps (1952–54) he spent a year in Paris, followed by three years at Christ's College, Cambridge studying modern languages. During that time he made sculpture and in 1957 married Lilian Odelle. King spent the year 1957–58 studying at St Martin's School of Art where Anthony Caro was teaching, and began making clay and plaster sculpture of a Brutalist-Surrealist type. He began teaching at St Martin's in 1959 and continued until 1980. In 1958–59 he worked as an assistant to Henry Moore and in the summer travelled to Greece on a Boise Scholarship. The first works made on his return were *Window piece* and *Declaration*. They were followed by sculpture in fibreglass. In 1964 he taught for a term at Bennington College, Vermont. His son Anthony was born in 1965. His first one-man show at the Rowan Gallery (where he has continued to exhibit) was in 1964 and in 1968 he represented Britain with Bridget Riley at the Venice Biennale. His principal studio at Clay Hall Farm near Dunstable was established in 1969. That year he spent three months in Japan making a major piece *Sky* for the Symposium of sculptors organised for Expo' 70. King won first prize at Socha Piestanskych Parkov, Czechoslovakia in 1969. For two years he was a Trustee of the Tate Gallery (1967–69); in 1974 he received a CBE, and in 1977 was elected an Associate of the Royal Academy. During the year 1979–80 King worked in Berlin and was a Professor at the Hochschule der Künste. He was appointed Professor of Sculpture at the Royal College of Art in 1980.

Phillip King at his Dunstable studio (photograph by Valerie Josephf)

One-man exhibitions

1957 Heffers Gallery, Cambridge
1964 Rowan Gallery, London and in 1970, 1972, 1973, 1975, 1977, 1979
1966 Richard Feigen Gallery, New York and Chicago: Isaac Delgado Museum of Art, New Orleans
1968 Galerie Yvon Lambert, Paris; Whitechapel Art Gallery; the British Pavilion 34th Venice Biennale (with Bridget Riley) and tour Stadt Galerie, Bochum and Museum Boymans van Beuningen, Rotterdam
1974/75 Kröller-Müller National Museum, Otterlo and tour to Kunsthalle, Dusseldorf; Kunsthalle, Berne; Musée Galiera, Paris; Ulster Museum, Belfast
1975/76 Arts Council touring exhibition to Mappin Art Gallery, Sheffield; Whitehaven Museum, Cumbria; Art Gallery & Museum, Aberdeen; Third Eye Centre, Glasgow; Hatton Gallery, University of Newcastle-upon-Tyne; Museum and Art Gallery, Portsmouth
1976 Oriel, Welsh Arts Council, Cardiff
1981 Hayward Gallery, London; Fruit Market Gallery, Edinburgh

Selected group exhibitions

1961 'British Sculpture', Jewish Museum, New York; 'British Sculpture', Madrid and Bilbao
1963 Third International Biennale des Jeunes Artistes, Paris
1964 'New Realists', The Hague & Dusseldorf; Documenta III, Kassel
1965 'English Eye', Marlborough-Gerson, New York; 'The New Generation', Whitechapel Art Gallery; 'London: The New Scene', Walker Art Center, Minneapolis and tour
1966 'Primary Structures', Jewish Museum, New York; 'Sculpture in the open air', Battersea, London; Sonsbeek '49, Arnheim; 'Chromatic Sculpture' Arts Council touring exhibition; 'New Shapes of Colour', Stedelijk Museum, Amsterdam and tour to Kunstverien, Stuttgart and Kunsthalle, Berne; 'Young British Sculptors', British Council touring exhibition to Berne and Dusseldorf
1967 Pittsburgh International, Carnegie Institute; 5th Guggenheim International Exhibition, New York
1968 'Interim', Whitechapel Art Gallery; Documenta IV, Kassel
1969 Tenth Biennale for Sculpture, Middelheim Park, Antwerp; International Sculpture Symposium for Expo' 1970, Osaka, Japan.
1970 'British Sculpture out of the Sixties', Institute of Contemporary Art, London
1971 'British Painting and Sculpture 1960–70', National Gallery of Art, Washington; McAlpine Gift Exhibition, Tate Gallery
1972 'British Sculptors '72', Royal Academy of Arts
1973 'Magic and Strong Medicine', Walker Art Gallery, Liverpool; 'Henry Moore to Gilbert & George', Palais des Beaux Arts, Brussels.
1975 'The Condition of Sculpture', Hayward Gallery
1976 'Arte Inglese Oggi', Palazzo Reale, Milan
1977 Silver Jubilee Exhibition of Contemporary British Sculpture', Battersea Park; 'The First Sculpture Park in Royal Parks', Regents Park
1979 The British Art Show, Arts Council touring exhibition to Sheffield, Newcastle and Bristol
1980 'Growing Up with Art', Leicestershire Collection, Whitechapel Art Gallery and Arts Council tour

Public collections

Arts Council of Great Britain

Bradford Galleries and Museums

The British Council

City of Rotterdam

Contemporary Art Society, London

Felton Bequest, Melbourne

National Gallery of Victoria

Galleria d'Arte Moderna, Turin

Government Art Collection

Gulbenkian Foundation

Kröller-Müller National Museum, Otterlo

Leicestershire Education Authority

Musée National d'Art Moderne – Centre Georges
 Pompidou, Paris

Museum of Modern Art, New York

National Gallery of Australia, Canberra

Royal Museums of Fine Arts of Belgium, Brussels

Scottish National Gallery of Modern Art, Edinburgh

State University of New York, College at Purchase

Stuyvesant Foundation

Tate Gallery

Ulster Museum, Belfast

City of Antwerp, Openair Museum for Sculpture,
 Middelheim

Cultural Centre, Adelaide

Sydney Opera House

Los Angeles County Museum

Leisure Centre, Osaka, Japan

Prefectural Museum of Contemporary Art, Toyama, Japan

Commissions

1969	Iron and Steel Federation of Japan and Mainichi Press for Expo' 70, Tokyo
1972	C. & J. Clark Ltd., Street, Somerset
1978	European Patent Office, Munich
1979	Romulus Construction Ltd., London

Selected bibliography

This list omits most newspaper reviews and discussions of group exhibitions.
The Rowan Gallery has compiled a complete bibliography.

Lynton, Norbert: 'London Letter', *Art International*, March 1964

Baro, Gene: 'Some London Galleries', *Arts Magazine*, March 1964

Robertson/Snowdon/Russell, *Private View*, Thomas Nelson & Sons, Ltd., Edinburgh, 1965

Forge, Andrew: 'Some New British Sculptors', *Artforum*, May 1965

Baro, Gene: 'Britain's New Sculpture', *Art International*, May 1965

Russell, John: 'Double Portrait – King and Riley', *Art in America*, May 1967

Fry, Edward: 'The Issue of Innovation', *Art News*, October 1967

Lucie-Smith, Edward: 'Phillip King goes to Paris', *Art & Artists*, January 1968

King, Phillip: 'British Artists at Venice, 2: King talks about his sculpture', *Studio International*, June 1968

Lucie-Smith, Edward: 'Two for Venice', and cover, *Art & Artists*, June 1968

Mullins, Edwin: 'British Art at Venice', *Daily Telegraph Magazine* June 21, 1968

Lynton, Norbert: 'The British Representation at the 34th Venice Biennale', *Art International*, Summer 1968

Kudielka, Robert: 'New English Sculpture', *Das Kunstwerk*, October/November 1968

Harrison, Charles: 'Phillip King – Sculpture 1960–68', *Artforum*, December 1968

Hilton, Tim: 'Phillip King', *Guardian*, July 10, 1970

Robertson, Bryan: 'Kingsize', *Spectator*, August 22, 1970

Gosling, Nigel: 'A New Mr. Smith', *Observer*, July 16, 1972

Brett, Guy: 'Phillip King at the Rowan Gallery', *Times*, July 18, 1972

Martin, Barry: 'British Sculpture', *One*, October 1973

Vaizey, Marina: 'Tucker and King', *Financial Times*, October 23, 1973

Seymour, Anne: Commentary, 'Henry Moore to Gilbert & George' catalogue, Palais des Beaux Arts, Brussels, 1973

Thompson, David: Introduction. Oxenaar, Rudi: Ed. 'Phillip King' catalogue, Kröller-Müller National Museum (Holland), 1974

Blotkamp, Carel: 'Sculptures and their relationship to time and surroundings', *Vrij Nederland*, May 11, 1974

'Kunsthalle: Iron Sculptures by Phillip King', *Berner Tagblatt*, October 20, 1974

Vaizey, Marina: 'The Shape of Change', *Sunday Times*, July 7, 1974

Fuller, Peter: 'Phillip King', *Arts Review*, February 21, 1975

Overy, Paul: 'Steel Forms and Product Design', *Times*, April 29, 1975

'Phillip King a Gallièra', *Le Monde*, May 2, 1975

Packer, William: 'New Sculpture', *Financial Times*, July 10, 1975

King, Phillip: Couturier, Michael: Interview, *Art Press*, July/August 1975

Lynton, Norbert: 'Sculptures by Phillip King' catalogue, Arts Council of Great Britain, 1975

Thompson, David: Sculpture Introduction; King, Phillip: Statement, 'Arte Inglese Oggi' catalogue, Electa Editrice, Milan, 1976

Ashton, Dore: 'New York Commentary – Guggenheim Sculpture International', *Studio International*, December 1967

King, Phillip: 'Colour in Sculpture', Statement, *Studio International*, January 1969

Paris catalogue (radio interview) 1975

Glaves-Smith, John: 'Phillip King: Sculpture', *Art Monthly*, July/August 1977

Robertson, Bryan: 'Grounds for Sculpture', *Harpers & Queen*, September 1977

Lynton, Norbert: 'Phillip King', *Art International*, September 1977

McEwen, John: 'Aspects of British Sculpture', *Artforum*, April 1978

Watson, Francis: 'Phillip King', *Arts Review*, April 13, 1979

Wakely, Shelagh: 'Phillip King', *Art Monthly*, No. 26 May 1979

Cooke, Lynne: 'Phillip King's Recent Sculpture', *Artscribe*, No. 18, July 1979

Robertson, Bryan: 'Export King', *Harpers & Queen*, September 1980